SPLENDOUR!
ART IN LIVING CRAFTSMANSHIP

SPLENDOUR!

ART IN LIVING CRAFTSMANSHIP

EDITED BY

Adam Busiakiewicz and John Martin Robinson
with assistance from David McKinstry

WITH PHOTOGRAPHY BY

Justin Paget

UNICORN

THE
GEORGIAN
GROUP

Published in 2017 by
Unicorn, an imprint of Unicorn Publishing Group LLP
101 Wardour Street
London
W1F 0UG
www.unicornpublishing.org

ISBN 978-1-910787-77-9
10 9 8 7 6 5 4 3 2 1

Designed by Blacker Design
Printed in England by Henry Ling Limited,
at the Dorset Press, Dorchester DT1 1HD

FRONT COVER: Study for *Neptune*
by Stephen Pettifer

BACK COVER: *Splendour!* exhibition,
photograph Justin Paget

THE GEORGIAN GROUP

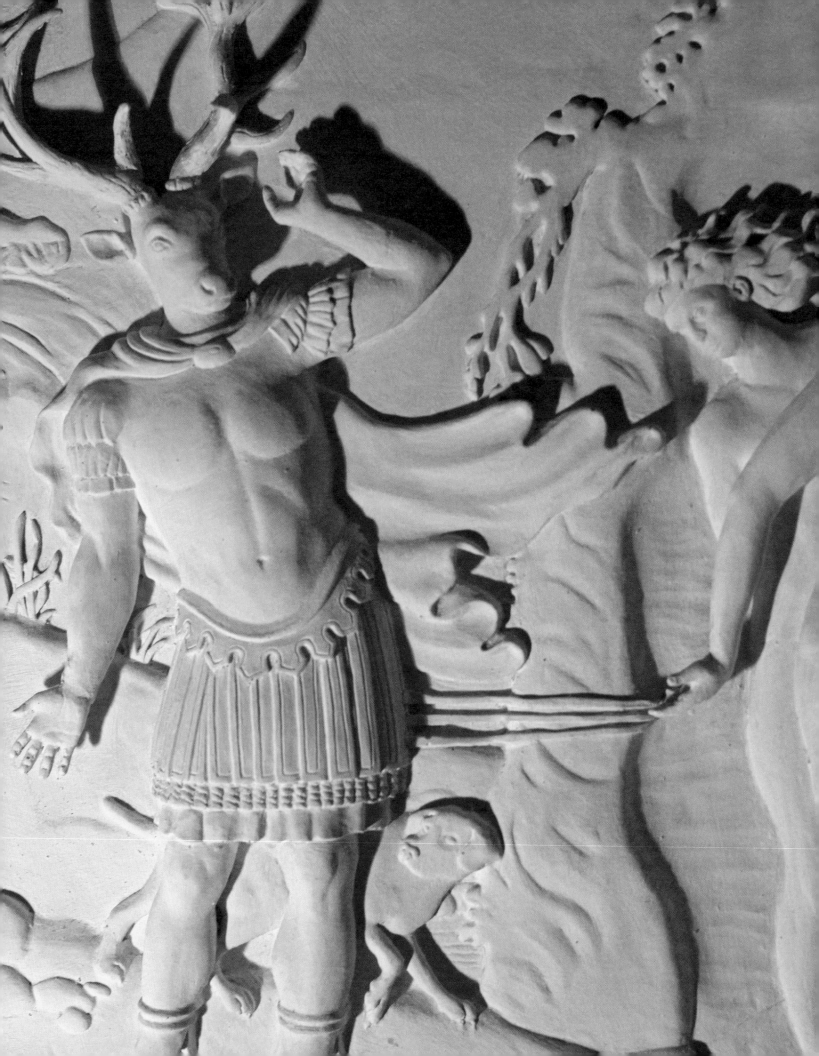

CONTENTS

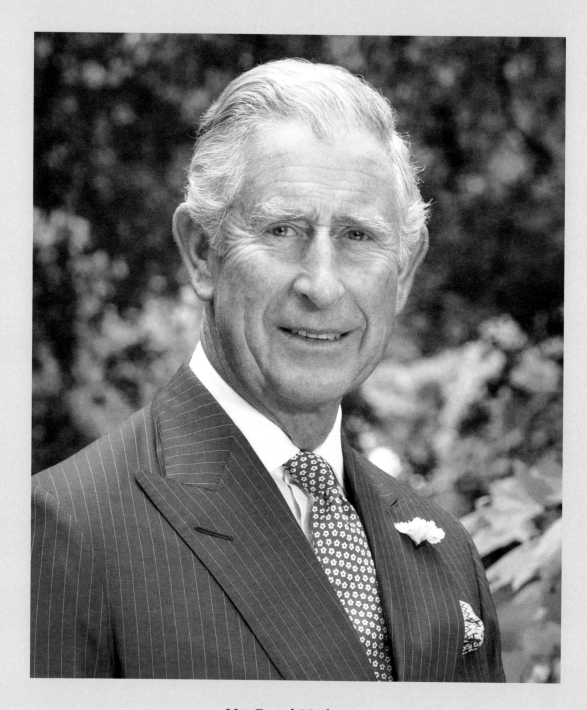

His Royal Highness
The Prince of Wales

FOREWORD

BY

HRH The Prince of Wales

PATRON OF THE GEORGIAN GROUP

CLARENCE HOUSE

I am delighted to be able to congratulate the Georgian Group on reaching its 80th anniversary. As Patron, I have been enormously proud to follow in the footsteps of not only my beloved grandmother, but also my great-grandmother, Queen Mary, the founding Royal Patron, in supporting this important cause.

It seems quite extraordinary, looking back, that such a precious part of our Nation's heritage should have been under threat, as it was in 1937. Although represented more often these days by incremental harm rather than the wrecking ball of the past, those threats have by no means gone away. While much has changed in 80 years, the commitment of the Georgian Group to the defence, rescue and appropriate restoration and adaptation of our Georgian environment has been steadfast.

In this work, I firmly believe that the celebration of traditional craft skills is vital. Without keeping these skills alive, we cannot hope to keep our buildings alive, nor to benefit from the lessons they embody in how to build beautifully for the future.

Architectural ornament, after all, is a language with its own grammar, dialects, beauties and subtleties. It is a language spoken not only on the drawing-board of the architect but – crucially – through the hands of the craftsman. The 18th Century saw a flowering of architectural craftsmen able to use that shared language to create some of the most supremely satisfying and humane buildings, imbued with the underlying, universal principles of harmony which, I strongly believe, underlie objective beauty.

But like any language, ornament needs to be taught. Craft skills, in particular, are incredibly perishable. They are best – one might say *only* – learned from master to apprentice. Without such a tradition, and without communication down the generations, the accumulated wisdom of past ages and practitioners is lost for ever.

That is why for some considerable time I have been arguing for more practical, hands-on teaching of craft, and then delivering it through the work of my Foundation for Building Community. I am particularly delighted that the Georgian Group has been working with my Foundation, as well as The Building Craft College, The City & Guilds Art School and The Art Workers Guild, of which I am proud to be Patron. It is only by associating the next generation of craftspeople with the existing master-craftsmen of this generation that these vital skills will be preserved.

Ever since its foundation in 1937, the Georgian Group has campaigned for the restoration or adaptation of 18th Century buildings using the skills and language of the 18th Century itself, and I am full of admiration for its courageous persistence, so often in the face of seemingly impossible obstacles and hostility.

This exhibition celebrates that 'Living Tradition'. In so doing, it provides a showcase for established craftsmen and artists who are at the very pinnacle of endeavour, and for the younger practitioners who will learn from them and take their skills into the future. Crucially, it also provides the inspiration and confidence to those commissioning work that – whatever may be claimed by the nay-sayers – in the matter of architecture and ornament we both can, and should, do everything our Georgian forebears could, and to just as high a standard.

I can only congratulate the Georgian Group, its Chairman and its Trustees for having the foresight to celebrate, as a tribute to the past 80 years of Georgian Group activity, the core skills which will allow it to promote the protection of Georgian fabric and the influence of Georgian taste over the next 80 years and beyond.

INTRODUCTION

The Georgian Group is launching its 80th-anniversary celebrations not by looking back, but by looking forward. The exhibition *Splendour! Art in Living Craftsmanship* has been driven by the wish to inspire new audiences to engage with architectural conservation, by providing a glimpse of the range of craftsmanship and skills that are essential to restoring historical work and sustaining traditional working methods.

As a charity, the Georgian Group has been committed to these ideals for decades, but we believe the long-term protection of all that is best in Georgian architecture, landscape and streetscape can only be furthered by engaging generations to come. We believe one of the ways to do that is to promote the extraordinary people and extraordinary skills that lie behind conservation work.

In designing our exhibition, we wanted from the start to recognise the importance of the talented craftsmen who care for our Georgian heritage with their skilled hands and deep artistic knowledge. We also recognise that certain crucial skills are under threat and that this unique group of people need extra support.

As a statutory body, we are proud of our record in saving key buildings and landscapes over eight decades of campaigning, but we acknowledge that today's environment is changing rapidly, with fast-tracked buildings and heedless development threatening our Georgian legacy as much as ever. To ensure we are ready for our work in the future is every bit as important as celebrating the achievements of years past.

Through mounting this exhibition, we are working to share our values with younger audiences through an educational programme. We want to reach out to future generations of budding conservationists, who will in time take over the cause of protecting Georgian heritage. To bring them into the fight, we must make them welcome in the Georgian Group. Our exhibition seeks to do that.

It falls to us to show the younger generation that our shared historic environment is one of which we must all be guardians. It has been a particular pleasure to involve so many millennials behind the scenes and as exhibitors – indeed it is only through their hard work and enthusiasm that this exhibition has been possible.

We would like to take this opportunity to say what a pleasure it has been finding and developing relationships with partners who can support one another and share resources. Our deepest thanks go to the City & Guilds of London Art School, the Prince's Foundation for Building Communities, the Art Workers' Guild, The Building Crafts College, the Carpenters' Company and the Young Georgians and to all the funders who have made the exhibition possible.

Finally, enormous thanks are due to our Chairman Christopher Boyle, whose vision inspired the exhibition, curator John Martin Robinson, designer George Carter, as well as the tireless energy of the Secretary and staff of the Georgian Group and the many volunteers whose efforts made it possible.

We hope you enjoy the ravishing work of our 50-plus exhibitors, from established master craftsmen to promising apprentices. It is a great pleasure to bring their work to our home at 6 Fitzroy Square.

Here's to the next 80 years of fighting to preserve the best of the Georgian age.

Khloe Sjogren-Cath, Directrice
The Campaign Committee

THE GEORGIAN GROUP

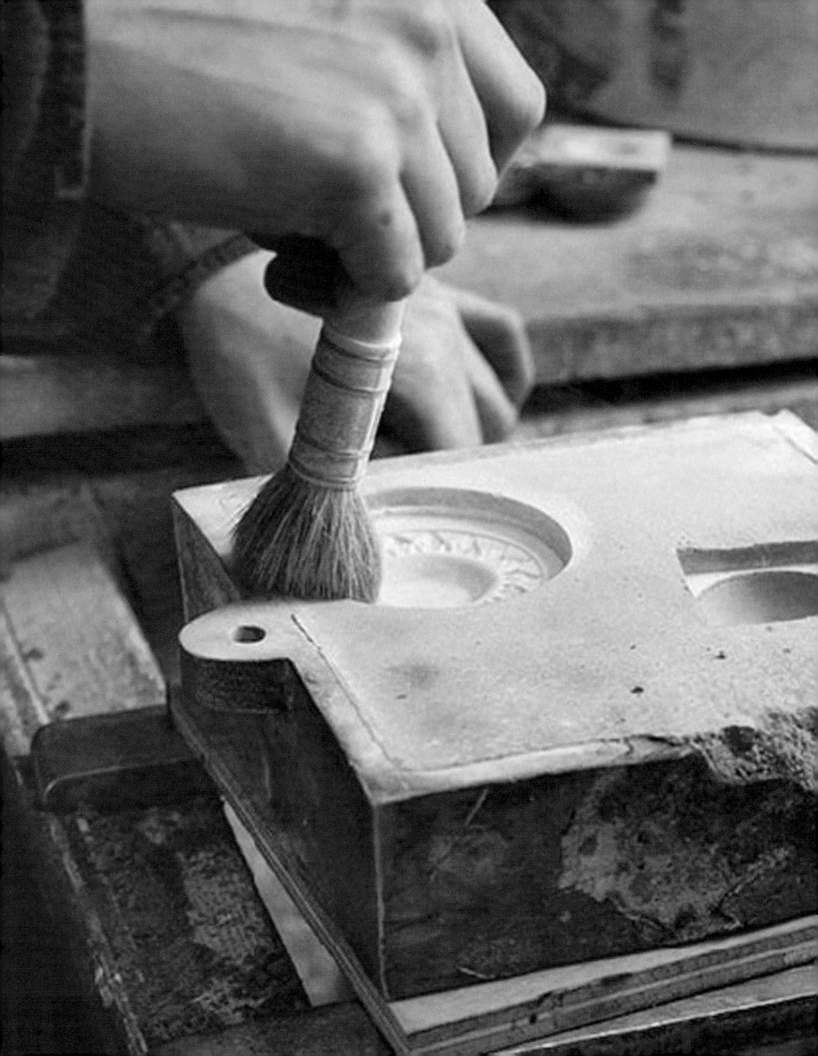

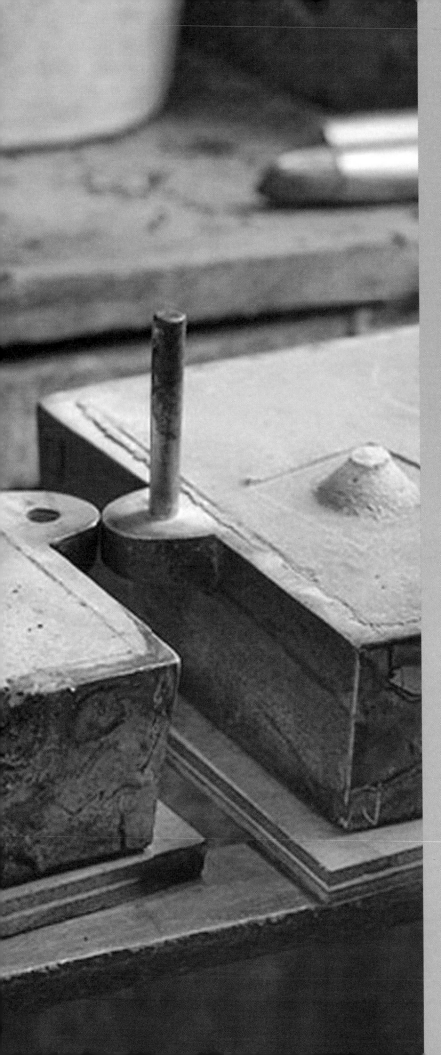

Essays

The following section consists of seven essays commissioned by the Georgian Group for the catalogue. Each essay contains both academic, professional and personal reflections on the main themes of the exhibition. The broad spectrum of writers and contributors, from architects, sculptors, carvers, legal professionals and art and architectural historians, aims to represent the Group's dynamic approach to conservation and craftsmanship in the classical tradition.

Metal casting process,
Collier Webb Foundry.

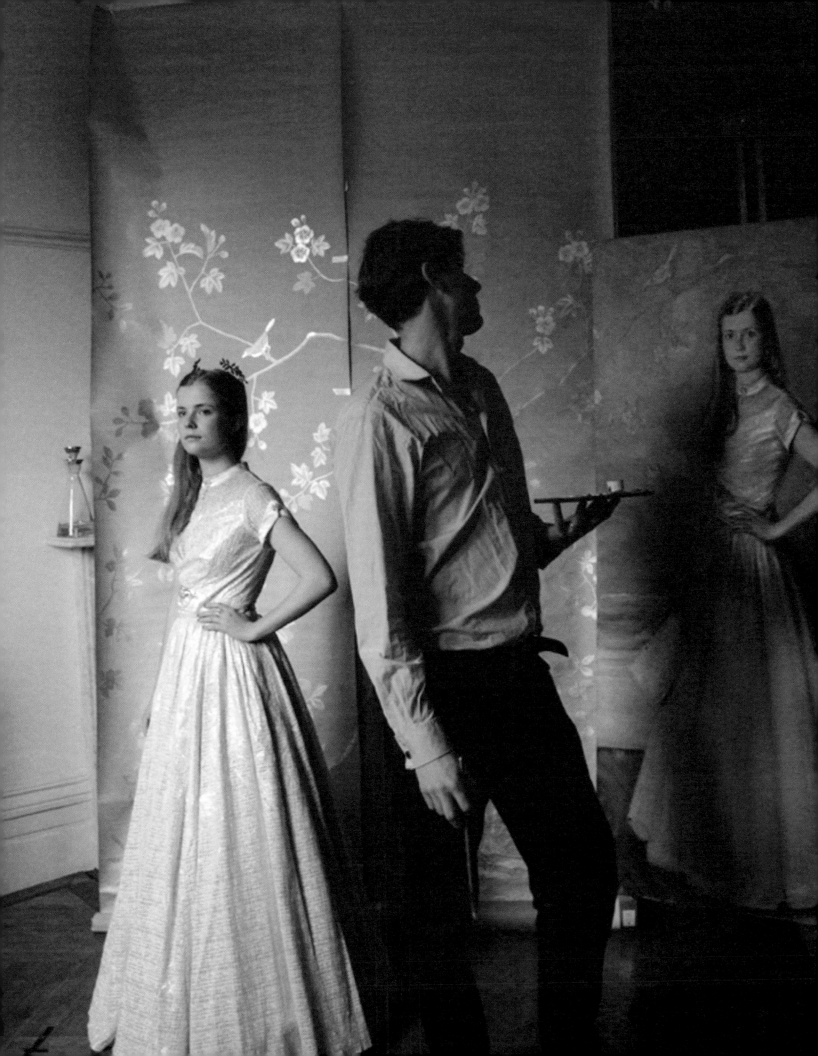

WHAT *IS* 'SPLENDOUR'?

CHRISTOPHER BOYLE QC, CHAIRMAN

This being a Georgian Group exhibition – entitled 'Splendour' – I want to explore the Georgian understanding of the word we use: *'splendour'*. What would 'splendour' mean to an eighteenth-century person? What would be its associations, its possibilities, its limits, its freedoms, its rules?

It is, I believe, only by thinking oneself into the eighteenth century, by totally immersing the psyche into the period – its sights, sounds, smells, understanding, assumptions and way of thinking – that one can fully appreciate the material survivals of the eighteenth century. For that reason, I am as fascinated by the century's music, its cooking, its politics, its dress and its deportment as I am by its buildings, landscapes and furniture. There is an invisible harmony which holds together the visible fabric: the warp to its weft.

It is, in my view, only by thoroughly understanding the eighteenth century that we can ensure that our treatment of its surviving fabric, and our learning of its lessons for creating today's fabric, is true to the original. Crucially, it is by being *true* to the original that we are freed simply from *copying* the original. By grasping that freedom we move in a single step from reproduction of a dead past to being in a living continuum with that past – to, in short, inhabiting 'The Living Tradition'.

That is what this exhibition is about: achieving a state where the pen that draws a filigree detail, the chisel that undercuts acanthus leaves, or the plane that describes an ovolo moulding, will each be imbued with the same spirit or – to use a favourite eighteenth-century word – the same *gusto*, as the pen, chisel or plane working 300 years ago.

When one looks for the genuine eighteenth-century meaning for a word we still use in the twenty-first century, one cannot go far wrong by starting with Johnson's celebrated *Dictionary* (1755).

He defines 'splendour' as 'magnificent', or 'pomp'; and 'splendid' as 'magnificent', 'sumptuous', or 'pompous'.

The word 'pompous' rings a jarring note to the modern ear – and, potentially, could play to those tired old Corbusians for whom ornament is anathema. We must also beware the travelling usage of words over 300 years. 'Pompous', for Johnson, carried not so much the current pejorative meaning, as one that savoured still of its origin: 'magnificent', 'grand' and … *'splendid'*.

But the sight of the word 'pompous' in association with 'splendour' puts one immediately in mind of Alexander Pope's famous lines:

You shew us Rome was glorious, not profuse,
And pompous Buildings were once things of use.

Pope addressed his *Epistle IV: Of the Use of Riches* to Richard Boyle, 3rd Earl of Burlington, the famous 'archi-tect earl', promoter of neo-palladianism, and patron of, among others, Colin Campbell and William Kent. Unlike the more moral tone of his epistle to the Earl Bathurst, concerning the effect of riches upon man, Pope's epistle to Burlington, this 'high-priest' of Jones and Palladio, focuses on the proper use of riches in buildings and external show.

The balance between ornament and beauty and the identification of the role of 'taste' within that, clearly exercised the poet, as it exercised the eighteenth-century mind more generally. Taste – and 'the Rule of Taste' – was a key desideratum, and nowhere more so than in Burlington's school of neo-palladianism, or Anglo-palladianism, intent on forging a new 'pure' architectural language drawing on the British work of Inigo Jones and the Italian work of Andrea Palladio. This was consciously in opposition to and in replacement of the 'corrupt' baroque-influenced oeuvre of Wren, Hawksmoor, Vanbrugh and their followers.

Thus, when, in the same poem, Pope warns Burlington:

Yet shall (my lord) your just, your noble Rules,
Fill half the land with imitating Fools;
Who random drawings from your sheets shall take,
And of one Beauty many Blunders make;
Load some vain Church with old theatric State,
Turn Acts of Triumph to a Garden-gate.

we hear echoed Burlington's rather graceless remark upon the unveiling of Wren's St Paul's (replacing the fire-burnt edifice which his hero Jones had re-clad): *'And when the Jews saw the Second Temple, they called to mind the beauties of the First Temple, and they wept.'*

It must be recalled that Jones was no enemy of ornament. Indeed, he famously described the exteriors of his buildings as like a public man, grave in his outward carriage, but the interiors *'licentious'* in their richness. Kent's work is no puritan eschewing of decoration, as Holkham, Houghton and, indeed, Burlington's own Chiswick bear ample witness. The altar of Palladio himself authorises as offerings to Dame Architecture the three Vitruvian principles: *fermitas*, *utilitas* and *venustas* (strength, use and beauty).

So, what is it, then, that allows splendour in ornament but decries excess? The secret is found in that same epistle of Pope to Burlington:

Something there is more needful than Expense,
And something previous even to Taste – 'tis Sense

The eighteenth century, as the Augustan Age, was the Age of Reason, the Age of Sense. The concepts of harmony and decorum imbued the creation of all things. Reason, to an educated man, delivered taste, by insisting on decorum – the proper ordering of things. To Palladio, decorum could dictate the use of which Orders for which buildings. More widely, it drew the line which, if crossed, would open oneself to ridicule. So, while Alberti divided *venustas* (his *amoenitas*) into *pulchritudo* (harmonic proportion) and *ornamentum* (surface decoration), both derive their proper limits from decorum – to which decoration is, of course, etymologically bound.

The Universe, World, Society, and Man's proper place within it are as carefully composed as the cosmos. As spheres move to their own harmonious music, so a well-ordered world operates by an harmonious sense of what is proper and appropriate to each and every situation. Abide by those rules and the result is an harmonious one. Depart from those rules and the result is discord. That is the principle, governed and directed by sense, which operating as taste, directs ornament to manifest beauty and harmony, and avoids discord, ugliness and absurdity.

By delving further into these resonances for the eighteenth-century mind, Religion and classical education would

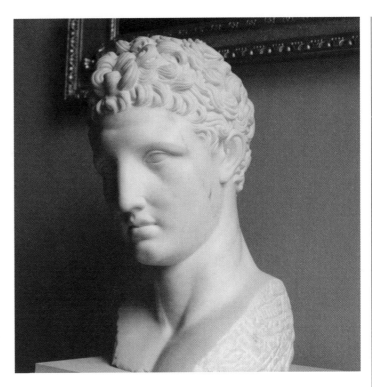

Corin Johnson's large-scale bust of *Hermes* in Carrara marble.

have taught him that Harmonic Order is divinely ordained. There is no greater authority than the writings of Ancients and of the Ancients, no greater writer than Homer.

'Splendour', our eighteenth-century mind would know, is none other than *Aglaea*, the youngest and most beautiful of the Three Graces. Her sisters, therefore, are Euphrosyne ('Mirth') and Thalia ('Good Cheer'). He would have seen them depicted, most engagingly, in famous paintings of the Italian Masters observed on his Grand Tour.

Our eighteenth-century classically educated mind would have not only known who Splendour and her sisters were (and the fact of their attendance upon Aphrodite, goddess of love and beauty), but would also recall her ancestry and her offspring.

Hesiod gives the parentage of Splendour as Zeus and one Eunomia, a handmaid of Harmonia, but – as importantly – the personification, herself, of 'Good Order and Lawful Conduct'. As one of the Horae, Eunomia's mother was Themis ('Divine Justice') and her sisters (Splendour's aunts, if you will) were Dike ('Earthly Justice') and Eirene ('Peace'). From such a parentage, how could Aglaea not be a most worthy Spirit to invoke? To the Georgian mind, therefore, Splendour is irrevocably associated with decorum and the proper order of things and is ennobled by the blood of the very king of the gods.

For our exhibition, the associations become even more apt. Homer's *Iliad* tells of how Aglaea became enamoured of Hephaestus (Vulcan), god of craft and craftsmanship, when he was expelled from Olympus for being lame.

Thus, in the eighteenth-century mind, on the best authority the Ancients could provide, *Splendour* is wedded to *Craft*. That is the very theme of this exhibition. Splendour is never anything but the daughter of her mother, Good Order. Such a concept would hardly be lost on Pope, whose translation of

The Iliad (1715–20) was the most celebrated of its day and made him the literary lion of Augustan England. He continues in his epistle:

'Tis Use alone that sanctifies Expense,
And Splendour borrows all her Rays from Sense

Who are then the offspring of this auspicious union, the children of Craft and Splendour, the grandchildren of Good Order, nieces of Mirth and Good Cheer, great-nieces of Divine Justice and Peace?

The eighteenth-century mind would have opened Hesiod again: they are Eulceia ('Glory and Good Repute'), Euthenia ('Prosperity and Well-being'), Eupheme ('Praise and Applause'), Philophrosyne ('Welcome and Kindness').

In short, to the Georgian mind – just as is true to the present day – when *Craft* combines with *Splendour*, the outcome embodies: welcome, well-being, good repute and praise.

That is the stuff of this exhibition.

23 Taviton Street WC

Euston 4959

Museum 19...

21, HILL STREET,
...R.W.1.

MARL...

...rt,

I duly s...
...acts from t...
...kindly sen...

I have n...
...he has rea...
...ty will be...
...Meetings

I mentio...
...me that it...
...Majesty's...
...after care...
...not possi...
...ns, which I...

I am, howe...
...£ 5.-.-. as...
...the funds...
...in future...
...nuary 1939...
...will be g...
...the Banke...

Of course...
...eing made...

I return...

...sq.
...hairman,
...e Georgian...
...28, Cork...

MARLBOROUGH HOUSE
S.W.1.

25th April, 1947.

Dear Mr. Acworth,

Thank you very much for
sending me a copy of the Georgian
Group "Visits – 1947" circular,
which I have had the honour of
handing to Queen Mary.

Her Majesty was very glad
to have this paper and said that
it will be of much interest to
her to read it.

Yours very truly,

J. Wickham.

Private Secretary to
H.M. Queen Mary

A.W. Acworth, Esq.,

...w...t, I congratula...
...of your Group. A...
...bound to be certain...
...ween the Society...
...been talking to Pal...
...you will agree to...
1. That large...
...discussed...
...between...
That...

THE CONTINUOUS PRESENT

The Georgian Group and Traditional Craftsmanship, 1937–2017

DAVID MCKINSTRY, SECRETARY

Our architecture and our language are the arts of England. But the art is impractical without its craftsmen. It is this that gives to architecture its corporate body. The art is not personified in a single figure. The minor arts are all flourishing, and all fall together. The leaves wither, and the long winter comes. We may conclude that it is unlikely it will flower again our lifetime.

SACHEVERELL SITWELL
British Architects and Craftsmen, 1600–1830, London, 1945

When Sitwell wrote his low-spirited view of the future of historic buildings and contemporary craftsmanship, much of Britain had been devastated by bombing and war in Europe was ongoing. The Georgian Group, founded in 1937, hibernated throughout the war, and although individual members remained very active, the survival of the Group in a post-war landscape was doubtful, where the 'rebuilding' of Britain often led to the demolition of historic fabric. Yet the Group not only survived; by 1947 it had been instrumental in achieving the statutory listing of historic buildings, and indeed that any building dating from before 1850 should be treated as listed until the statutory lists had been completed. In addition to this, the Group campaigned for the preservation and repair of vast swathes of bomb-damaged fabric in the face of a severe shortage of materials, and, often very successfully, campaigned against the demolition of country houses. Such successes demonstrate the determination of both the Group and the public to save and protect the physical links with the national heritage in a period when one may have thought it impossible.

These achievements required both a public appreciation of Georgian buildings and architects and craftsmen capable of restoring them. While there were many exemplary restorations of Georgian buildings in the post-war period, often attempts had to focus on preserving and reinstating the spirit of the building. Surely that generation of conservationists and craftsmen should regard our own age with envy, when decades of education, research and technological development should have made it easier than ever to continue the living legacy of traditional craftsmanship? Yet we have only to look around the historic environment today to see that, all too often, outside of 'heritage projects' or 'conservation areas', more than a lifetime of work has been disregarded. The ethos of the Group was that while statutory protections for the historic environment were vital, the true focus of its efforts would be to make such protection

Letters from The Georgian
Group archive.

less necessary through public education. Rather than passively relying on local planning authorities to prevent harm, the property owner should be encouraged to reverse damage and halt decay.

While the wholesale loss of Georgian buildings is thankfully now a rarity, all too many are still affected by thoughtless and ill-informed alteration, left to decay, or even fall victim to deliberate harm. A risk-averse commercial sector, a financially beleaguered government, a housing shortage; all of these are used to excuse the neglect and maltreatment of the national heritage. But if a nation under rationing and other hardships could find time and skills to repair and conserve its heritage, and to do so as a priority, then there really is no excuse for not doing the same, and far more, today. As the Georgian Group celebrates eighty years as a conservation charity, it is worth reflecting on our founding principles:

To save from destruction or disfigurement Georgian buildings, whether individually or as part of a group, monuments, parks and gardens of architectural and historic interest and, where necessary, encourage their appropriate repair or restoration and the protection and improvement of their setting.

To stimulate public knowledge and appreciation of Georgian architecture and town planning; of Georgian taste as displayed in the applied arts, design and craftsmanship, and its influence on later periods.

The Trustees of the Group recently reaffirmed those aims in advance of the eightieth anniversary, and recognised that these objects are mutually reinforcing and therefore need to be pursued together.

Top: Kingston House, Kensington, demolished 1937.

Above: Kingston House site today.

Therefore the Group's eightieth anniversary is marked with a special programme of events focusing on the best contemporary craftsmanship as it relates to the Georgian environment. In so doing, the Group seeks to inspire the public to challenge the pessimistic, despondent and utterly erroneous assumption that intervention in the historic environment must necessarily be jarring, in materials and design, and without reference to our enormous repository of inherited national craft skills, many of which were honed to the peak of virtuoso perfection in the long eighteenth century and are practised with equal skill today. It was not for nothing that Sacheverell Sitwell called the years following 1600 'the continuous present, those centuries of a universal language in the arts of life'.

The works displayed in this exhibition combine both of the Group's charitable objects. For, by stimulating public knowledge and appreciation of Georgian craftsmanship, it is easier to save Georgian buildings and landscapes from destruction and disfigurement, and, in showing the happy influence of the eighteenth century on later periods, it is easier to encourage the appropriate repair of historic fabric today.

The Georgian Group's earliest manifestation was as a pressure group, in reaction to the zealous demolition of Georgian London; not least that of John Nash's Regent's Street and the Adam brothers' Adelphi Terrace. The period between the Great War and the Second World War saw the demolition of thousands of British buildings; many others were abandoned or partially destroyed. It was during this period that houses such as Wingersworth, Derbyshire were lost. With no government support for owners and no legislation to prevent destruction, even buildings of the highest architectural and historic merit were dismantled and sold for their scrap value. The practical legacy of the Georgian terrace was also obliterated

in cities across the United Kingdom, often in favour of development, which has since been demolished due to its rigid inadaptability for present inner-city needs.

In the 1930s an educated minority decried the destruction of original eighteenth-century fabric, both in its own terms, but also as a loss of basis for contemporary design. Far from being saved for reasons of nostalgia, the twentieth-century sympathy towards the Georgian legacy arose from a belief that it offered a rational design code with which to challenge a commercial interest intent on filling the public realm with a disparate array of individualistic buildings, united only in their disregard for the conventions of public good manners and rational town-planning.

The distinctive point about the formation of the Georgian Group is that it did not seek to preserve buildings and places simply because they were 'old', but because of their design qualities or aesthetic merits. Indeed, those who founded the Georgian Group were not only anxious to protect the built heritage of the long eighteenth century from destruction, but also to prevent it being altered or replaced by that which was, in the words of Lord Derwent to the House of Lords, 'jerry-built, shoddy and an agony to the eye'. However, simply building something loosely 'classical' was never accepted as an excuse for a badly conceived building. The monolithlic sub-Wrenian 1930s flats of Grosvenor Square were not seen as justifying the destruction of eighteenth-century houses any more than the deeply underwhelming American Embassy of the late 1950s, and the mechanical 'Georgianism' of 31 St James's Square added insult to the injury of the demolition of Norfolk House in 1938. Rather, the key argument of the Group's aesthetic crusade was that the architecture of the long eighteenth century was worth preserving not only for its historic value, but also for its current design value and its

ability to inform contextual modern buildings of the appropriate scale, fabric and character for their location.

On 4 January 1938, on BBC programme *Farewell Brunswick Square*, the Group's Vice-Chairman, Robert Byron, and committee member John Summerson argued that modern town-planning had to involve preservation of historic buildings; that the past should inform and inspire modern design. Town-planning should not fail to relate to historic buildings or produce schemes necessitating their total clearance. While the demolition of historic buildings is more unusual today, the argument that modern development ought to respect and enhance the historic environment is a daily battle for the Group. Indeed, in most cities in the United Kingdom, the harm caused to the settings of Georgian buildings, through over-scaled and poor-quality new buildings, has become far worse.

During the 1938 broadcast, Byron was anxious to point out that the design merits of the Georgian inheritance did not lie simply in the ornate works of the period, but equally in vernacular and modest buildings. In the view of the Georgian Group the Georgian aesthetic suited English cities, because, Byron stated, it corresponded;

> *…almost to the point of dinginess, with our national character. Its reserve and dislike of outward show, its reliance on the virtue and dignity of proportions only, and its rare bursts of exquisite detail, all express as no other style has ever done that indifference to self-advertisement, that quiet assumption of our own worth, and that sudden vein of lyric affection, which have given us our part in civilisation. These are exactly the characteristics that London ought to express.*

Top: Munster Square, The Regent's Park demolished after 1945 but proposed for demolition since 1936.

Above: The Kingston House site today.

What is immediately apparent is that the Group was not seeking to preserve the terraces of Georgian cities because they were ancient, but for reasons relating to their character, appropriateness and adaptability. That the public agreed with these values is evidenced by the surge in donations and membership following the broadcast.

The Second World War brought new challenges, but the massive redevelopments of the post-war period spurred the revival of the Group under a constitution outlining its charitable purposes. It was in the post-war years that the Group began to extend its concern and expertise towards the country house, which was threatened with destruction. In the period after 1945 early members of the Georgian Group, not least James Lees Milne, tirelessly campaigned for the National Trust to take on as many 'at risk' houses as possible. While the days of total demolition are no longer as extreme as in the mid-twentieth century, the Group is still engaged in debate and practical advice regarding the British country house. The recent fire at Clandon Park, the ongoing decay of Piercefield Hall, the future of Wentworth Woodhouse all require attention, along with the many private houses on which the Group consults every year.

Today the Group's concerns still relate to the overall context of Georgian heritage. Alterations which do not harmonise with the original fabric, the loss of a historic collection in its original context, repairs poorly executed or completed in inappropriate materials; all form part of the Group's concern, alongside its statutory role in the planning process. Therefore the Group sees appropriate craftsmanship as essential, certainly for the repair and maintenance of historic fabric, but also for new work in historic contexts. While it may well be unwise to extend a medieval tithe barn in the style of Ely Cathedral, it is equally unwise to extend a Georgian house by means of glass boxes and copper louvres, as though it is some arcane fragment of a period so dead that there is no longer any sympathetic context in which it can sit comfortably. Incongruity of contemporary intervention is not the hallmark of good heritage stewardship, especially for buildings whose design aimed at harmony and integration of all of a building's components. The belief that 'of its own time' means new work executed in general accordance with the principles first espoused at the 1932 MOMA exhibition is not logical, although used enthusiastically by both educated architects and crass developers to defend disfiguring alterations to the historic environment. And concerns that, unless visual dissonance is created, it will somehow become impossible to distinguish between original fabric and later work, displays little confidence in the sensibility of the skilled craftsman or the abilities of the architectural historian.

Today the Group aims to protect historic buildings through providing advice to owners and architects and through our role as a statutory consultee in the planning system. We retain an active interest in works affecting the public realm and designed landscapes. Our annual Architectural Awards promote excellence in design and conservation as well as new work in the classical tradition. In its casework and educational activities, the Georgian Group advises owners, local authorities and churches on works to the historic fabric and setting of structures built between 1700 and 1840.

Therefore the legacy of positive and proactive conservation, and appreciation of our Georgian heritage, as established by our founding members, continues apace in the twenty-first century.

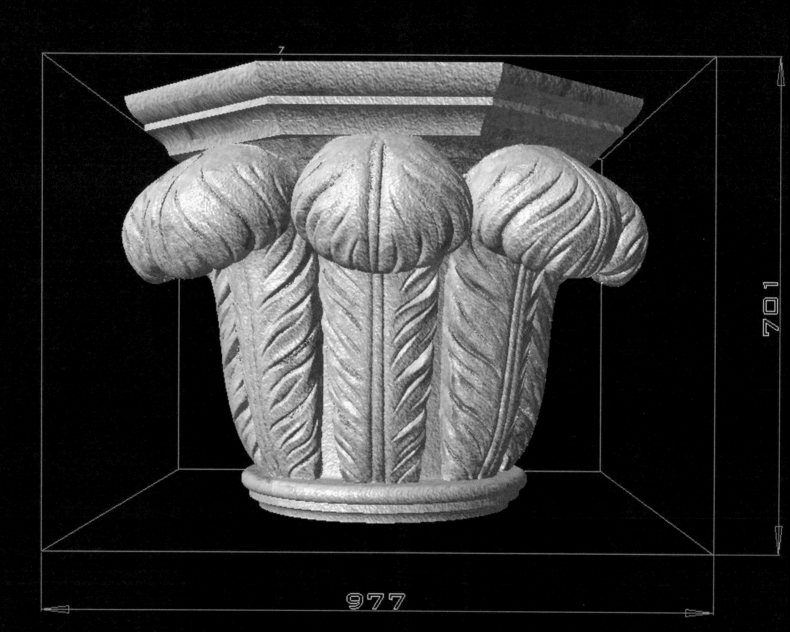

7

701

977

A BRIGHT FUTURE FOR THE CRAFTS IN OUR POST-INDUSTRIAL AGE

HUGH PETTER, VICE-CHAIRMAN OF THE GEORGIAN GROUP

'... *of course you could not do that nowadays because, the trouble is, there just aren't the people with those sorts of skills anymore.*'

How often have we all heard this urban myth trotted out as we look at some highly crafted historic object. Anyone could be forgiven for thinking that the crafts in the early twenty-first century are in a state of terminal decline. Myths of course develop for a reason and so it is worth looking for a moment at some of the issues that may underpin this widely held belief.

Increasingly onerous health and safety legislation and employment law over the past thirty years have made the prospect of running a large craft studio a challenging one, which many craftsmen have chosen to avoid by working in much smaller groups. As a consequence, the majority of craft-based businesses employ less than half a dozen people and are often based in sheds at the bottom of gardens, or in converted industrial buildings with little kerb-presence. Many of these businesses, therefore, have a relatively low profile and rely upon the support of local customers and/or well-informed clients seeking a specialist service. Their relative obscurity certainly adds fuel to the myth, as people struggle to know where to go to find these specialised skills.

The rise of the conservation movement after the Second World War sustained a number of traditional craft skills. Formed initially to repair war-damaged buildings and as an antidote to the brave new world of International Modernism, the conservation movement has provided plentiful work for generations of craftsmen, albeit primarily on the repair of historic buildings rather than in originating new work. This predominance of repair work to fragile historic structures often requires old-established techniques to be employed in preference to more modern technology. In turn, this can create an impression in the minds of some that traditional crafts skills are stuck in a time-warp and are therefore increasingly irrelevant to the challenges facing more mainstream new building projects.

Opposite: Digital model produced from the full-size clay model.

29

Below: Initial sketch of ostrich feathers capital modelled upon the Prince of Wales's three-feather badge, shared by Surrey County Cricket Club, by Hugh Petter.

Those who wish to study a traditional craft may struggle to find information about all of the courses that are available, because many of the institutions where these subjects are offered – for example, the Building Crafts College or the City & Guilds of London Art School, or the American College of the Building Arts in Charleston, US – are independently owned. These colleges offer courses of very high quality but they tend to operate in relative isolation with a profile lower than the larger higher-education institutions.

In recent years, governments in the Western world have been keen to promote craft training as a viable alternative to an academic university qualification. Significant sums of money have been available for apprenticeships. However, this is not always as well targeted or well co-ordinated as it should be. Similarly, upon graduation, craft students benefit from spending some time with an established practitioner to acquire professional experience before launching their own business. However, because of the nature of the majority of craft firms, few established craftsmen are willing to saddle themselves with an apprentice, as this brings with it a whole raft of employer responsibilities which they would rather avoid. As a consequence, many graduates from crafts courses end up pursuing careers in other fields.

Yet all is not gloom and doom. Indeed, green shoots abound: for example, the Art Workers' Guild in London, founded in 1883, was the cradle of the Arts and Crafts movement, which quickly spread all over Europe and across the Atlantic to the US. It is a club where new members are elected by peer group review and where regular lectures and events are arranged to provide a point of focus for the members, many of which otherwise work in relative isolation. It is currently growing at a rate of about 15% a year and its membership of over 300 spans some 80 different craft, design, fine and applied arts disciplines. Over the past 128 years the Guild has spawned over 80 other kindred societies, many of whom use its building in Central London for their meetings. It is estimated that over 30,000 people who are connected in some way with the decorative, fine and applied arts cross its threshold each year, and yet it has never received a bean of public money.

The Building Crafts College in London has over 1,000 students and is expanding year on year in response to the demand for the courses that it offers. The City & Guilds of London Art School, is in similarly good heart. The American College of the Building Arts in Charleston in America is

thriving and has grown very quickly from its foundation fifteen years or so ago to become recognised internationally as a significant institution. In Russia, the museum at Tsarskoe Selo near St Petersburg set up a craft workshop to rebuild the Catherine Palace, which had been destroyed during the German occupation. That workshop now employs over 70 people and undertakes both conservation work and new projects all over the country.

Whilst conservation work may well require old techniques, modern technology can help in many other areas. The internet, for example, can be used to help raise the profile and accessibility of small craft businesses and can make it easier too for people to work together regardless of where they are in the world. The International Network of Traditional Building Arts and Urbanism (INTBAU) for example, with active chapters in many countries across the world, is growing rapidly since its foundation at the turn of the century. The resulting increase in accessibility and profile of craftsmen from this sort of virtual network, in turn, creates a larger and more readily accessible market for specialised crafts businesses.

The so-called 'five axis machine' was developed originally in Italy for the car industry but has found a new use in stone, joinery and other craft workshops. An object, such as a swag or column capital, is modelled in clay by a craftsman; it is then scanned to create a virtual three-dimensional computer model. The machine then proceeds to carve the stone using progressively finer chisels as work proceeds. It can carve in eight hours what it would take a man to carve by hand in eight days. The craftsman still creates the original object in clay and finishes the stone copy by hand, but much of the relatively mechanical, time-consuming and mundane work of carving the object out of the block of stone can be done more quickly and cheaply than would otherwise be the case,

keeping costs to a commercially viable level and leaving the craftsman with more time to concentrate on areas of work where their specialist skills add most value.

In the nineteenth century the writings of Pugin and Ruskin were hugely influential internationally and underpinned both the Gothic Revival and the Arts and Crafts movement. They saw architecture as the 'mother of the arts' and architects were encouraged to let the creative genius of the craftsmen shine through by allowing them to design the fine detail of buildings upon which they were working. Ruskin, ever an idealist, became increasingly frustrated by the lack of success with this aspiration, but he failed to understand that many of the craftsmen at that time had been trained to produce high-quality work designed by others, not to design it for themselves. In other words, they simply did not have the skills and education to innovate their own design work.

In contrast, in our post-industrial age, people in the Western world have more wealth, education and leisure. As a consequence, not only are more able school-leavers going into better-run crafts courses than ever before, but also people are changing jobs in mid-career and many are entering the crafts having had a first career in another subject. As a consequence, the gene pool of craftsmen is significantly broader than in previous ages with more well-educated, articulate and entrepreneurial people. Increasing visual acuity is evident everywhere, especially in this the age of the smartphone and tablet. Given the unprecedented amount of opportunities to explore creative urges and interests, due to more leisure time than ever before, it is understandable as to why there should be a renaissance of appreciation for the hand-made and finely crafted object.

This exhibition, *Splendour! Art in Living Craftsmanship*, coinciding with the eightieth anniversary of the foundation

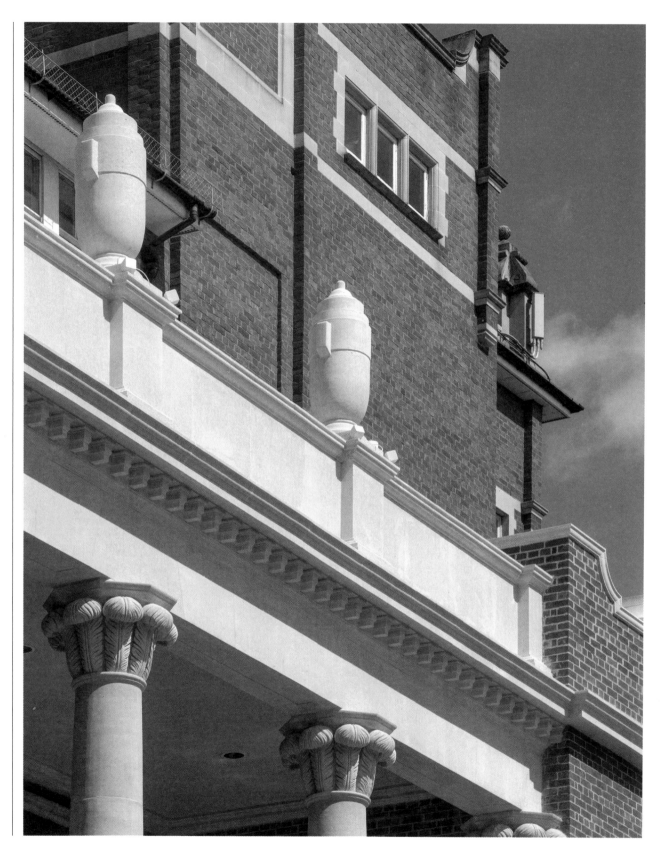

Opposite: Column capitals at the Oval cricket ground in London, part of the new pavilion portico, completed in 2013.

Below: Three feathers modelled at full size in clay by Charlie Gurrey.

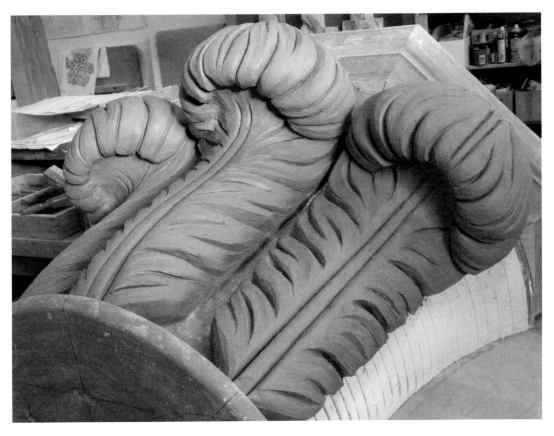

of the Georgian Group, is a welcome opportunity to bring together and to celebrate the rich seam of craftsmen, artists and designers now working actively within the United Kingdom and overseas. These people are not only doing a wonderful job in renovating and conserving our treasured historic buildings and monuments, but they are also producing vigorous and fresh new work of comparable quality. This pool of talent includes not only established figures, but also ever-swelling ranks of younger people, who are finding their services ever more in demand.

It is a time for optimism and for careful action. The green shoots which are now visible must be nurtured and cherished to ensure that the wonderful work that is underway across our islands to conserve our rich architectural heritage continues, and that the classical tradition, which plays such a central part in the national architectural character of the United Kingdom, can continue with fine new buildings, constructed and embellished with fine, innovative and vigorous details of the highest quality.

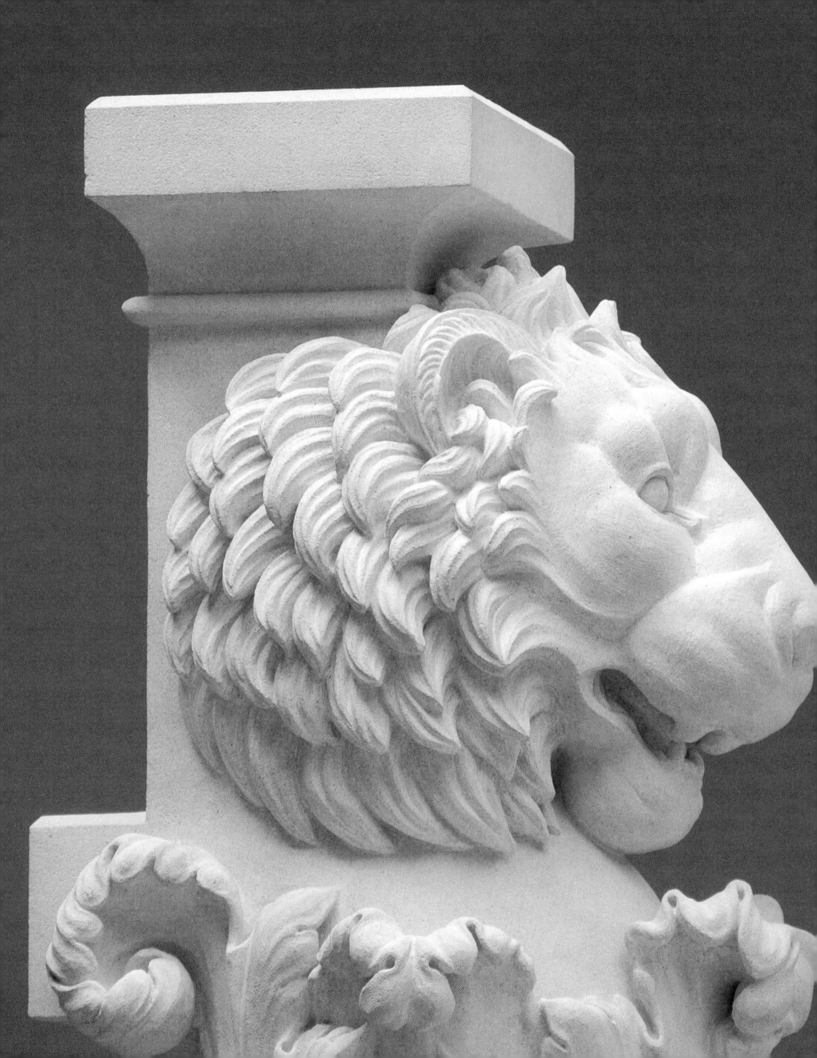

THE MARK OF THE CHISEL

Training to work in a grand tradition – the past and the future
for the architectural carver

TIM CRAWLEY

I am an architectural sculptor and stonecarver, with thirty-five years' experience of working on the restoration of historic buildings. I have also designed new work for historic locations utilising the rich vocabulary of architectural ornamentation found in much of our stone architecture. This may be derived from foliage forms, such as the acanthus of ancient Greece, or the oak and hawthorn of the medieval northern forests, or it may be figurative, ranging from the draped figures in Gothic niches to classical gods or figures from mythology. I feel very fortunate to have enjoyed an unbroken career of hands-on making, and hope to continue until I can no longer lift hammer to chisel.

During my career I have worked on many buildings from the Georgian period. In architecture the period is generally seen as a time of classical restraint and elegance in design, which can sometimes seem slightly chilly, although undeniably refined, sophisticated and meticulously crafted. But ornamentally it was also a time of experimentation and innovation.

My work as a carver has covered most of these developments. In terms of sheer scale, my biggest project was to redesign and restore the monumental lions and unicorns that Nicholas Hawksmoor slipped past the Church Commissioners onto the base of the steeple at St George's, Bloomsbury around 1743. Baroque in style, this work belongs to the opening of the period; by its close, between 1809–19, James Wyatt was working in the Gothic idiom as the architect responsible for the re-casing of the richly heraldic exterior of Henry VII's Chapel, which I was in charge of recarving between 1992–96 in my role as Head Carver at the old-established company in Cambridge, Rattee & Kett.

I was also responsible for the remaking and re-installation of the pasticcio that forms the centrepiece of John Soane's personal architectural museum behind his house in Lincoln's Inn Fields. I highlight these Georgian snapshots from my career as they give some impression of the variety of work a professional architectural carver may be called upon to tackle.

Carved and moulded ornament is one of the features of historic architecture that distinguishes it from the contemporary. In our current age of minimalism its decorative nature has been looked upon as a redundant form, but in the past, used judiciously, it had an important role and was employed to emphasise and articulate various key elements of building design. Its imagery is still recognisable and accessible to all levels of society, giving period architecture a particular quality that draws people to it, and which is recognised as a precious gift from

Opposite: Detail of a lion trapezophoro by Felix Handley, a recent graduate of the City & Guilds of London Art School and winner of the Master Carvers Annual Prize for 2016.

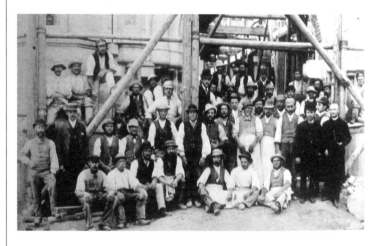

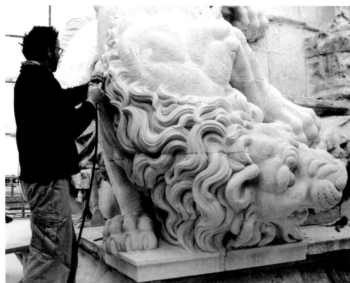

Top: Staff of Rattee and Kett Ltd, outside the Catholic Church, Cambridge, built 1890s.

Above: Tim Crawley at work on a lion sculpture for St George's, Bloomsbury, one of Hawksmoor's six London churches, completed around 1745.

the past that as a culture we cherish and strive to preserve. Ornamental detailing derives from a long tradition, and to be done well it requires a great deal of skill and knowledge from the craftsmen who make it.

The value we attach to work of this kind is measured by the efforts we now make to preserve it. A huge amount was lost in the twentieth century through the effects of war, followed by an almost iconoclastic disregard as city centres were redeveloped. But the dawning recognition of what we were losing led to the growth of the conservation movement in the 1970s, and what remains of our historic building stock is now jealously guarded. If we wish to hand down this precious asset to future generations, we need the skills and knowledge of the craftsmen for repair and restoration when eventually required. As far as possible we now make every effort to preserve original work, but all materials have a finite life, and at some point restoration will be required, and this is where the skill, experience and sensitivity of the historic building craftsman is required.

In the past, the healthy living tradition of stone and woodcarving as a part of a common language of building meant that carvers could be found in builders' yards across the country. The traditional way of learning skills was through apprenticeship, the system developed in the later Middle Ages, which came to be supervised by craft guilds and town governments. A master craftsman employed young people as an inexpensive form of labour in exchange for formal training in the craft. Apprentices usually began at ten to fifteen years of age, and would live in the master craftsman's household. Most apprentices aspired to become master craftsmen themselves on completion of their contract (usually a term of seven years), but some would spend time as a journeyman and a significant proportion would never acquire their own workshop, moving to new areas in search of work. The basic principle of the method was learning by doing, under the eye of the master and experienced practitioners, incrementally gaining experience and knowledge of the tools, materials and practices particular to the craft. But always, the principle of learning by doing and copying was fundamental.

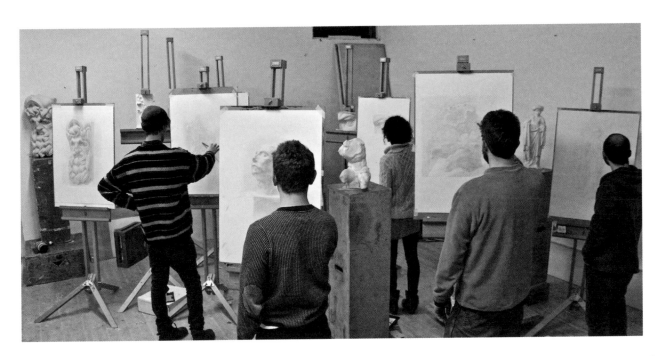

Carving students working from plaster casts in the Tonal Drawing class at the City & Guilds of London Art School. Drawing is the foundation of carving technique.

In the Victorian and Edwardian periods up until the First World War the industrialisation of the country and the wealth of the Empire led to a huge quantity of carved work being commissioned for major church, governmental and institutional buildings across the country. Large specialist companies developed to satisfy demand, such as H. H. Martyn of Cheltenham, and Farmer & Brindley of Lambeth. This was a golden age for the craft of carving, and these huge shops were ideal schools for architectural carvers, who would be exposed to a continuous stream of high-quality work.

I myself was lucky enough to experience the tail end of this grand tradition, when in 1989 I took up the position of Head Carver at Rattee & Kett Ltd in Cambridge. This Cambridge Master Builder still directly employed all types of traditional building craftsmen: bricklayers, lead workers, joiners and cabinet makers, and lettercutters, as well as wood and stone carvers. The quantity, quality and complexity of the masonry and carving work that was done during the large-scale restoration of Westminster Abbey between 1975–95 allowed a whole generation of young craftsmen to hone their skills to a very high level, and many are now established as senior figures within the trade. In order for this system to function, continuity of employment was key. The security of direct employment allowed for the fostering of relationships between masters and apprentices, which facilitated the exchange of knowledge, and consistency of workflow allowed sufficient time for the accumulation of solid experience.

The only way to learn a practical skill is through practice. This may sound tautological, but cannot be emphasised strongly enough. Learning starts with very simple exercises,

37

repeated over and over. As facility with the tools and knowledge of the materials increases, exercises of greater complexity are introduced. Reference to good examples is essential, and straight copying is part of the process. Critics of this type of learning will maintain that it does not lead to understanding – it is simply learning by rote. Not so; it is learning by intelligent memory, such that the carver is making a judgement about the work with every blow of the mallet, constantly adjusting the pressure, direction and angle of the chisel in order to cut the material effectively according to purpose. The purpose of repetitive practice is to instil 'muscle memory' into the carver, so that the technique becomes second nature. The removal of material then becomes secondary to the consideration of the effect – that is the modelling of the surface to manipulate light, and more particularly shade, in order to define form. In the case of the historic carver, this form is ornamental, the drawing of which will itself need to be practised in order to be fully understood. Designing using this language of form demands yet another layer of learning.

In 1999, when I left the security of the Rattee & Kett workshop after a decade, the writing was on the wall for large traditional building companies of this type. The relentless pressure of market economics and the system of compulsory competitive tendering, which was introduced for building projects using public subsidy, meant that companies had to cut costs in order to win contracts. One of the easiest ways to do this was to cut training and no longer attempt to provide continuous direct employment to craftsmen. The contractor became king.

The working pattern for carvers became one of self-employment, in which everyone became a sub-contractor, bidding for work against one another on price, and moving from job to job wherever it could be found. We have to accept that for the traditional building craftsmen of today, the supportive workshop of the past is but a distant dream. The market economy is the harsh and unforgiving environment in which carvers now attempt to operate.

The disappearance of the large-scale and long-established workshops, the new patterns of employment and the intermittency of demand call for a different approach to the training of carvers and other traditional building artisans if we wish to conserve these skills. Rather than learning on the job, and being paid for this, aspirant carvers can learn in a college setting, in which the workshop environment of the past can be recreated. Key to the success of this model is the employment of

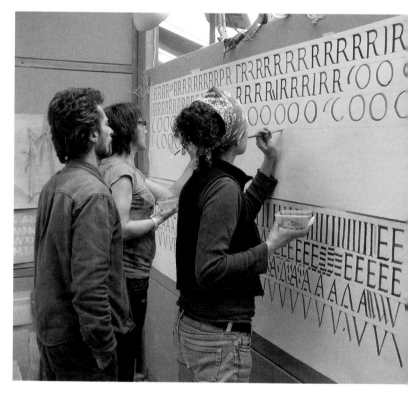

Above: Lettering tutor and students at the City & Guilds of London Art School, practising the construction of the Roman alphabet using brushes.

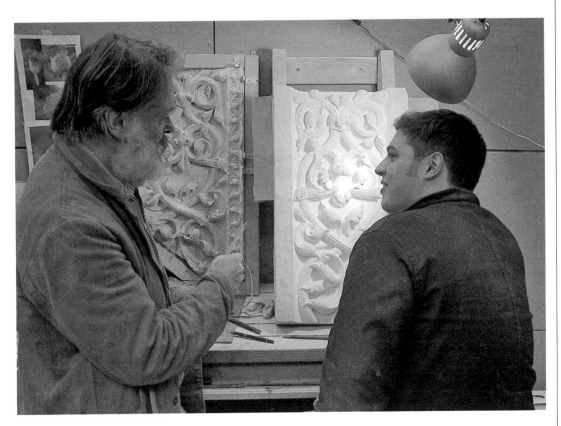

Stonecarving tutor and student at the City & Guilds of London Art School discuss the finer points of the Gothic foliate relief ornament from the Basilica of Saint Denis, Paris.

practising professionals as tutors, so that the teaching remains focussed on the skills and techniques that are currently used. The traditional craft skills of carving and letter-cutting can be complemented by the art skills of observational drawing, modelling, and the study of the history of art, architecture and ornament. Alongside this, there can be instruction in the professional practice skills of estimating, programming and workshop management. This is the programme of study for stone and woodcarvers in the Historic Carving Department at the City & Guilds of London Art School, which over the years has been very successful in launching the careers of new carvers.

Survival in the work environment I have described is tough. In general, carvers are an idealistic and romantically inclined group, whose primary motivation is not one of self-enrichment. They take up the profession out of a love of making and doing, and in the belief that the rewards of creativity and craftsmanship will sustain them. With a strong will and the commitment and motivation that comes from the love of the work, it is just about possible to make a living as a carver, and I believe that whatever the circumstances, there will always be a small number of us who will take forward the tradition.

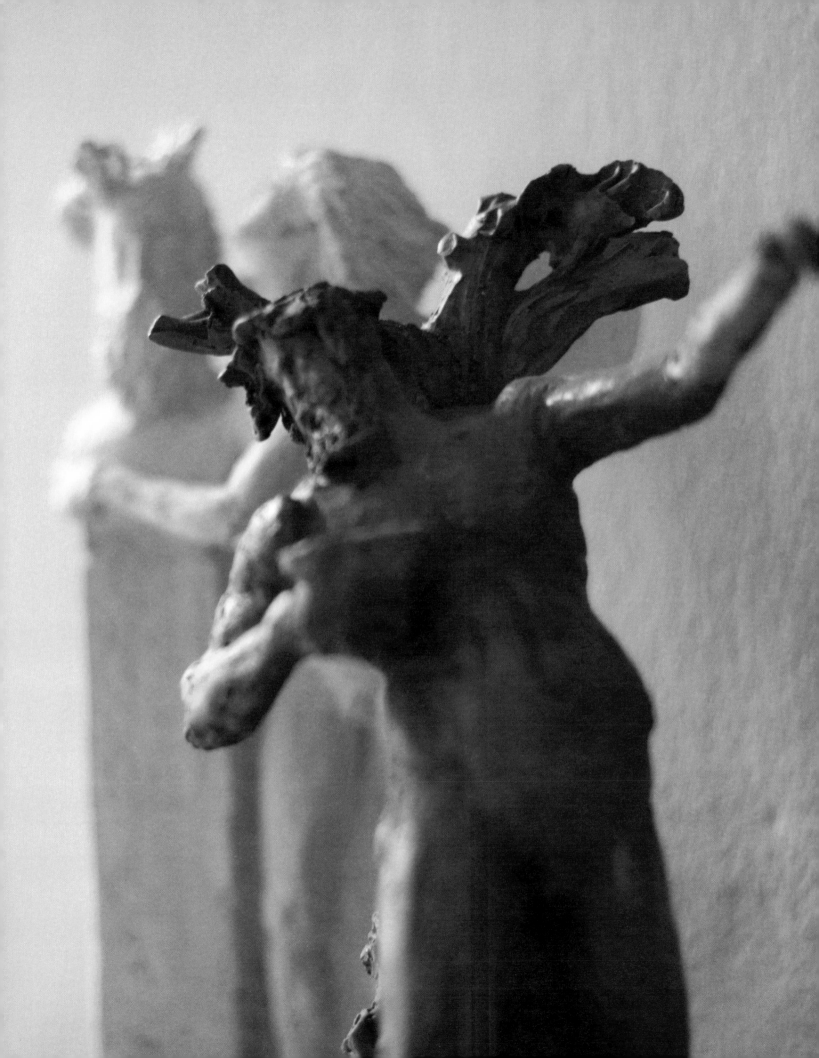

'... BUT HE'S GOOD WITH HIS HANDS'

ALEXANDER STODDART, HM SCULPTOR IN ORDINARY IN SCOTLAND, DL

There is an old tradition, sustained in widely differing cultures over thousands of years, that the possession of a manual skill indicates a deficit in intelligence. In the West the prejudice can be dated back to Plato, for whom *techne* (the skill in fashioning things) indicated both mental and moral deficiency. In this view he was perhaps carrying on an aristocratic tradition, reified in philosophy by Heraclitus, the progenitor of Western logocentricity, whose great book, deposited in the Temple of Artemis at Ephesus, served as rigidly prescribed reading for the entire thinking of the Greek world – and well beyond Greece as the centuries passed. 'In the beginning was the Word, and the Word was with God, and the Word was God.' This famed, late Hellenistic utterance is purely derived from the words of the Weeping Philosopher.

Some time before Heraclitus, in Judea, possibly around 600 BC, the process of compiling Exodus and the Pentateuch began; the codification and legal institution of episodes from Hebrew mythology. Here we discover, in the authentic and authoritative mythological voice (myths are *great truths*, not falsehoods at all) that the making of images, and so many of the crafts and hand-skills associated with their production, excites the wrath of God. The Commandment against image-making is numbered two on the Tablets, while that against murder is way down the priority list at six. And the offensive object raised at the foot of Mount Sinai (I mean the Molten Calf) is directly opposed, symbolically, by these Commandments: text versus image. In this ancient story the roots of contemporary artistic conceptualism is supplied with its moral 'cover'. Jehovah is very pleased when a prize-winning artist is defined as 'one who cannot and will not draw.' It is therefore both natural (Jehovah is simply a form of Mother Nature) and entirely predictable that the modern-day Godfather of the word-as-artwork, Ian Hamilton Finlay (1925–2006), should arise in Reformationist Scotland, that he should have been a life-long Heraclitean and Platonist, and that the late-modern, conceptualised arts authorities in power still to this day should regard his work as a kind of Old Testament.

Finlay was, by contemporary arts standards at least, a profound thinker, but what attracts the authorities to his *oeuvre* above all is that he farmed out the production of the objects he conceived to a body of so-called collaborators, many of whom (myself included) received their instructions over the telephone. These people, skilled, unsung and under-paid, were kept in the background not so much by Finlay himself, but by the agents who would husband his works and pass them into the market. There was an anxiety that 'Finlays' could be made without Finlay there. If a 'collaborator' rose to prominence in his or her own right, then there would be an adulteration of the currency that Finlay alone supplied the intelligence, and that the rest were simply 'makers'. To be called a 'maker' in contemporary arts circles these days

The Wisdom of Silenus by Alexander Stoddart.

is to signify that one is not, indeed, an artist *as such*. I myself was once told, face to face, that I was 'a very good *maker*, but what we need is a concepts person'. This was said by a female arts-bureaucrat from Swindon, a member of what was called 'The Commissariat for Cultural Change'.

Into my studio in Paisley I often welcome urchins off the streets to assist me in my 'making'. They are generally boys and girls who wash up as refugees from the Scottish art schools, with others aiming to apply to an art college after a stint at my studio. The ones who are unlucky enough to go to art school return during the holidays with terrible stories of neglect and discrimination (if they are stupid enough to disclose to their guards that they have even met me). They are, to a man, exhausted and shocked by the amount of pseudo-philosophy they are expected both to ingest and spout. Those who pitch up possessed of a 'Degree' arrive in some distress at their sudden realisation that they emerge into the world fantastically qualified but commanding No Known Skills. They feel bereft and traumatised. Art School selected them from school on the basis, partly, of their portfolio and the drawings contained within, at which they had worked very hard, so that by the time they had taken their finals they could draw a cheese-plant with their eyes shut. Once in, they were promptly and menacingly told that drawing was irrelevant and to persist in this criminal activity would endanger their sacred Degree. Terrified of their parents' disappointment, they dutifully took the pledge and were rewarded accordingly. Then they were kicked out into the world to stack shelves at Tesco, leaving the authorities to gloat over their achievement – that once again they had neutralised another unit of the community's image-making power and demoralised if not destroyed one individual *innately disposed* to replicate the world in careful scratches with a point of some sort.

The urchins at my studio are first taught to weld, then to mix a bucket of plaster, then to sweep (by far the most testing task of all – for some simply *will not* sweep) and then they get a plaster bust of Augustus to copy in clay. If only they had been to Art School, some residual ghost of conscience within

them regrets, then the copying should not be so desperately difficult. But they are all beginners.

Why should hand skills in art draw patronising looks and smiles? After all, Alfred Brendel is tremendously dexterous and he is regarded as a sage. But music paints no picture, makes no replication of the objects of the world. Nature is not furiously prosecuted by the composer as it is by the painter. Nature hates to be looked at, just like any person or hound, and Nature, said Heraclitus, loves to hide. Perhaps this is the kernel of the problem; that in a deep collective psychology somewhere a vast, evolutionarily functional aversion to the act of visual representation makes our species turn upon the unnatural freak who draws or fashions. The painter is felon enough – but what of the sculptor, who not only represents but does so at the expense of space itself? His hand skills are ten times those of the painter, and he also wears boots and a muddy coat, and knows how to conduct himself among the hard men of the foundry or building-site and is too busy properly to be termed a gentleman. Perhaps the tutors at the Art Schools are simply trying to upgrade the social status of their charges, as in a finishing school. But I believe that the possession of skills in art ought to be perfectly integrated into the development of a person as an artist, and that if he has no natural aptitude he will not be allowed to have his works ghost-sculpted on pain of exposure as a fraud. Thus his moral disposition, manifested in his diligence and self-reliance, comes to the fore as the primary director of his talent towards serious and profound artistic ideas. If he is found to be disinclined to sweep, then he is likely a philistine; a prejudice, true, but a serviceable one.

There is an old Greek idea, popularised in the era of the 'comfort philosophies' emerging after the conquest of Hellas by Alexander the Great, that 'taking pains' in any endeavour was instrumental in rendering that endeavour virtuous – *ponos*.

Above: Sandy in his studio surrounded by other commissions. Photographed by David Mitchell, 2014.

Right: Stoddart's 'urchins' Lindsay and Kas assisting with the sculpting of the clay figure.

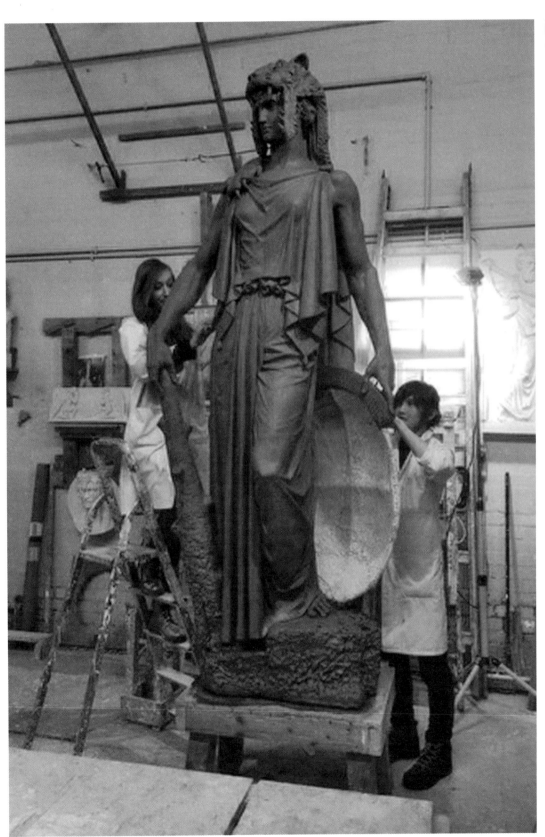

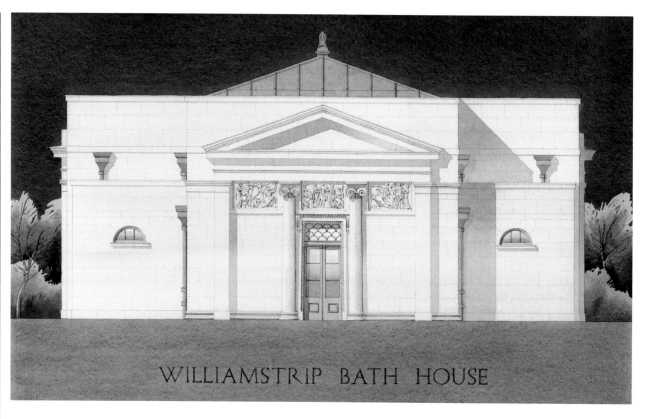

WILLIAMSTRIP BATH HOUSE

Williamstrip
Bath House,
Gloucestershire,
designed by
Craig Hamilton.
The frieze above
the entrance
was designed
and executed by
Stoddart.

It was in particular adopted by the Cynics of the Hellenistic age, whose patron deity was Heracles, and for whom the lowliest manual labour was a privilege to undertake. In architectural art the finest effects are achieved by a self-abnegatory commitment to hard physical work. There is a moral profile too, and this is widely recognised by the Rust-belt, blue-collar constituency, which is so often assured by the ruling mandarins that certain modernist buildings, devoid of adornment and dependent upon mere occupancy for their charm, are in fact better than they look. They appear to be easily made, and this strikes a note of alarm. Where's the pain, the people ask. Where's the *ponos*, hence the virtue? To what extent has the building observed proper social form, and gone to great trouble to justify its appearance in the body-politic, with graces, if not airs? It looks sullen and adolescent. Significantly, plate glass is the ashlar of today, for it is a material that notoriously defies any working. Hands-free, it is rolled in a mill then slammed into position. What adornment it might receive is generally in the form of frosted wording, and if not this then simply the sight of the smart individuals within, gathered in an interior so bland that it does not distract from their presence. These occupants are the sculpture-scheme, and they move around to prove their fitness on the biological level; they are always so beautiful. The smart set functions as a kind of projection upon the exterior skin of the structure, constantly changing but always representing 'us'. By contrast, fully decorated buildings, accommodating extensive works of sculpture, introduce a rival humanity, unchanging, larger than we are, set higher than us too, and nearly immortal. A Cosmic resentment of this kind of thing lies at the root of Adolf Loos' accusation of criminality in ornament. Presumably the rough men who work these effects are accessory to the crime.

Not rough, but *roughened*. John Ruskin seldom visited the studio of his friend Thomas Woolner, the Pre-Raphaelite sculptor, because the conditions there were so harsh that he became chilled and ill afterwards. His attitude was widespread, even in the nineteenth century. In the cases of the two greatest architectural sculptors in Scotland during the Victorian era, Handyside Ritchie and John Mossman, both were only reluctantly admitted into polite society, the latter being awarded merely an associateship of the Royal Scottish Academy very late in his career of working the statues, grave memorials and mighty architectural sculpture-schemes in Glasgow and the West of Scotland. As for Ritchie, a favoured pupil of Thorvaldsen himself, he died at not an old age, after something 'went wrong' – as we always say when we think of this immense artist's mysterious end. I think the often sad stories of the decline of the great sculptors result from their social stigmatisation as manual workers, feet and fingers freezing for half the year and a constant drip at the nose. The very conditions themselves all too often bring about their deaths: Canova's from a tumour behind the sternum from working the bow-drill; Patric Park's from helping a station porter lift a heavy trunk (they are instinctual lifters); Archibald Dawson's from silicosis; John Henry Foley's from a chill caught during large-scale clay modelling; Peter Lawrence's from lockjaw, and so on. William Behnes, shortly before his death, was found drunk in a London gutter with three pence in his pocket. Paisley's own John Henning, decorator of the Athenaeum Club and Decimus Burton's Hyde Park Arch, was left destitute in London after the universal piracy of his *magnum opus*, the reduced intaglio restorations of the Parthenon friezes. This apprentice carpenter had taught himself Greek, Latin and Hebrew, despite being 'good with his hands'. He was a son of Phidias.

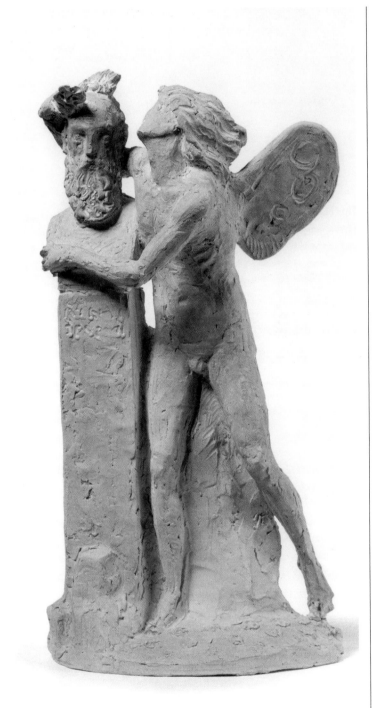

Anacreon's Grave by
Alexander Stoddart.

45

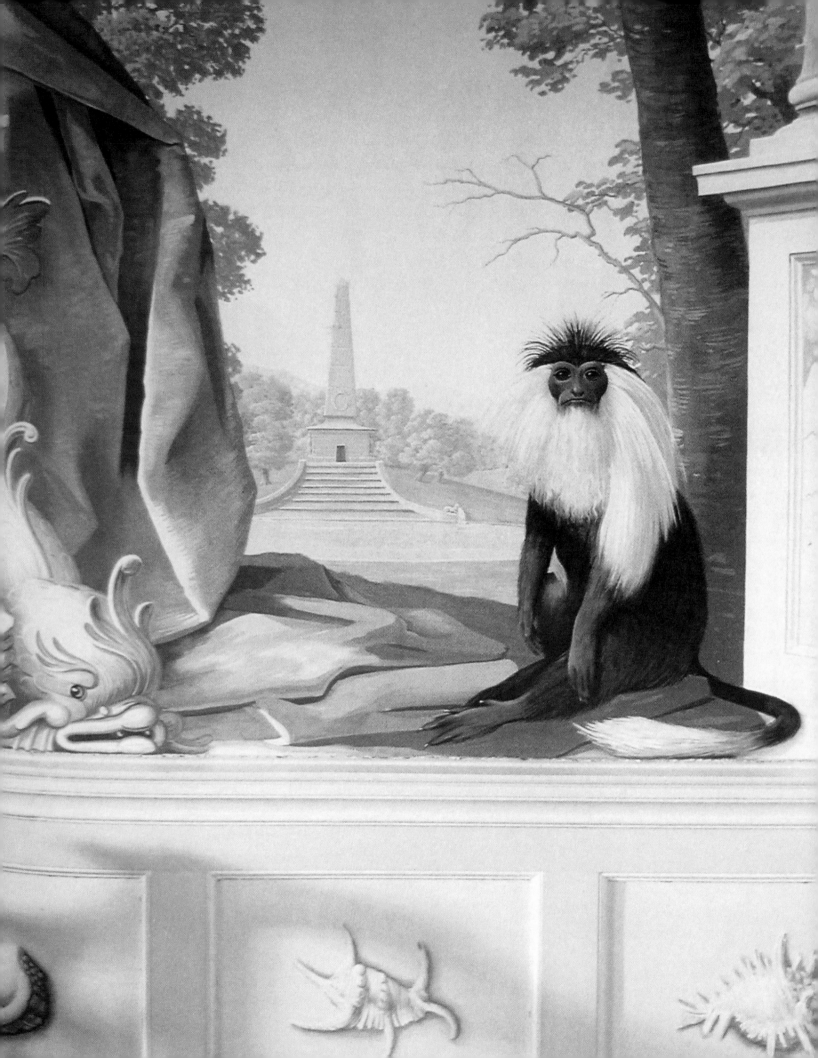

NOTES FOR A NEW APELLES BRITANNICUS

Five Painters, Antient & Modern

JAMES INNES-MULRAINE

*Words should be employed as the means, not the end; language is the instrument,
conviction is the work.*

<div align="right">SIR JOSHUA REYNOLDS</div>

The painters in this exhibition exemplify the living tradition in a varied way, but with a similarity of approach. Architectural painters Graham Rust, Alan Dodd, and Alexander Creswell together with portrait painters Philip Cath and Dick Smyly are distinct modern talents, feeling themselves to be as contemporary as any other living artist. Yet their practice draws on the inheritance of their profession. To paint, in traditional media and materials, from life, and to use compositions based on an inherited model can be as modern and immediate as the work of any self-consciously contemporary artist. The immediacy of their approach and craft is the most obviously human aesthetic in this display of contemporary craftsmanship.

Painting in the eighteenth century was controversial at the time in terms of subject matter and techniques, if less so than the painting of the twenty-first century. Yet its formations and allegories were also linked to a living tradition of observation, architectural reference, and craft skill. While the studios of Gainsborough and Reynolds replicated the configurations of their masters, the overwhelming aim was clear, that what one commissioned *was* a Gainsborough, or a Reynolds.

Of the architectural painters exhibited in *Splendour!*, Graham Rust has been exhibiting at the Royal Academy since 1965. Trained at the Regent Street Polytechnic School of Art, the Central School of Arts and Crafts and the National Academy of Art in New York, his designs for dining-room panels at Kinross House in this exhibition show his virtuosity in depicting nature. His best-known work, the vast Kentian *Temptation* at Ragley Hall, painted over a decade in the 1970s, includes a colobus monkey, which future generations of visitors will swear can be seen flickering in the draught.

Alan Dodd has been restoring and recreating Georgian interiors for over forty years. His murals open Arcadian vistas in the walls of his patrons' houses, and conjure plasterwork, tapestries, drapes and chiaroscuro papers in *trompe-l'oeil*. Dodd's arduous training would be familiar to his Georgian predecessors: he studied for eight years at the Maidstone School of Art and Royal Academy Schools, where he learned to draw from antique sculpture. His practice began in 1975 with an advertisement in *House and Garden* which secured three commissions

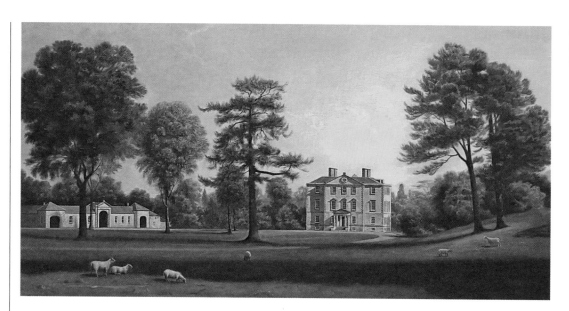

*Mortonhall,
Midlothian*, by
Dick Smyly, 2009.

at once. Dodd's best-known work includes enrichment of the staircases at Spencer House in London and Worlingham Hall in Suffolk; painting Lord Leighton's previously unexecuted Pompeiian ceiling at Sir John Soane's House; and recreating Antonio Zucchi's lost landscape panels at Home House. Among the Old Masters, Dodd admires the Italian Primitives, particularly Piero della Francesca and Sassetta. In *Fonthill Abbey 1976–79* he uses both their palettes, with brilliant white against a lapis sky, also conveying the feeling that painting is a stage where heaven and earth meet.

The artists in this exhibition combine a respect for traditional practice with some openness to modern technology and methods. There the easy comparison ends. Most significantly, Dodd began his career as a Surrealist, just as some would describe artists of the Renaissance. Just as we understand human behaviour through satire, so too does the surrealist by distortion. Dodd's favourite modern painters are Giorgio de' Chirico and Paul Nash, whose presence is felt in *Fonthill Abbey*. This painting takes a piece of installation art, empty of people, where architecture melts into the sunlight or resolves itself into geometric units, hinting at parallel realms as much as at the classical past.

The sublime is certainly a quality associated with the work of Alexander Creswell, who is that rare being, a highly successful self-taught painter, who has become one of the world's leading watercolourists. Having painted a remarkable series of watercolours after the fire at Windsor Castle, as well as many other views of ruins and abbeys, classical houses and Baroque façades, he became official watercolour painter to HRH The Prince of Wales. Colour is always a strong emotional feature in his work, often with indigo contrasting with siena and flame tones. Creswell has painted many views in Italy, including Venice and Sicily, and is, perhaps surprisingly, also an expert marine artist, capturing the movement of sea and sky.

While Creswell must be called a romantic, Dick Smyly is perhaps the only painter in this group who might be considered a pure Augustan. His portraiture, which is in the collection of patrons from HRH The Duke of Cambridge to the Royal Air Force Club, records a way of life that still largely moves to Georgian rhythms. Smyly trained in Florence at the Charles Cecil Academy in 1991–92, where he drew from the nude in the morning and from casts in the afternoon, learning to paint portraits by the sight-size method, as practised by painters from Velazquez to Sargent. Smyly's working practice is again a mixture of the old and the new. It can be difficult

to distinguish the hand of different painters from this studio, but Smyly has a colour key that is all his own, cheerful and sometimes bright.

The proprietorial aspect of the subjects of these paintings provides a link between them all. The eighteenth century was above all the century of property, and more than anything, of Protestantism. Commissioning a painting of one's house, one's family or one's horses and dogs, was the ultimate celebration of the individual, no longer restricted to the aristocracy. The portrait had to look like the subject, not only to reflect his status, but also to evoke his personality. His property, and his prosperity, was not only his definition of self but the basis of the entire legal and parliamentary system. The profusion of paintings of his helpers, his animals, his houses, have immediate response to modern eyes. It is easy to see ourselves as part of the Georgian tradition of celebrating beauty and material comfort. Smyly recognises that the portrait painter's job is like that of a director, who must coax the best possible performance from their actor.

Like many of the craftsmen practicing today who are negotiating traditional materials with modern tastes or modern methods with traditional tastes, Philip Cath's practice oscillates between his formal portraiture, and his contemporary work, which uses traditional painting language subversively in the orthodoxies of modern painting. For this work he paints collaboratively with his wife under the name Mr. and Mrs. Philip Cath.

After completing the prestigious Goldsmiths MFA programme with acclaim, they were nominated for the Caitlin Art Prize in 2014. At their recent solo exhibition at Almanac Projects, *Mr and Mrs Philip Cath & Lovers*, chaste modernists were taken off guard by the hanging of a traditional portrait of a curator, which is anathema in a white cube space.

Philip Cath came to painting while reading history at Oxford and studied under Will Topley at The Prince of Wales's Drawing School. His portrait style is self taught, based on first hand observation of originals, and he only paints from life sessions. He asserts the pathos and restraint of portraiture is elusive, if working from photographs. As a portrait painter Cath casts himself in a traditional mould, inspired by and endlessly studying the work and techniques of the great portraitists, particularly the unfinished works of Sir Joshua Reynolds and George Romney. It is a loss to the craftsmanship of portraiture that the tradition of studying under masters has been extinguished as art schools privilege the contemporary over traditional. Deskilling is promoted as a hallmark of contemporary art, much to the frustration of the casual viewer.

Fortunately, the painter's materials and pigments remain virtually unchanged since the Georgian period, and sensitive makers of these pigments take particular care to produce them with historic qualities and formulae.

In this exhibition Cath's portraits of *Miss Faith Waddell as Splendour* and *The Collins Sisters* show how well painting can simply describe people in a domestic environment, just as the Georgians understood it. Both were created in the same rigorous, living tradition as the other works in the exhibition.

Splendour! uses a pretty young woman as an allegory, whilst *The Collins Sisters* are daughters of the craftsman who handmade the adjacent pier glasses. The sisters are the youngest members of the Georgian Group, showing enthusiasm both for the life of the craftsman and the Society, and looking directly to the future. In the words of Sir Joshua Reynolds: *vivet in posterum.*

CONSERVATION IN A MILLENNIAL CONTEXT

ADAM BUSIAKIEWICZ, CATALOGUE EDITOR AND YOUNG GEORGIAN

Things men have made with wakened hands, and put soft life into are awake through years with transferred touch, and go on glowing for long years.

And for this reason, some old things are lovely warm still with the life of forgotten men who made them.

D H LAWRENCE
Things men have made

Over the past few months membership of the Young Georgians, a group specifically set up for those aged 35 and under, has doubled. The Group's 80th anniversary exhibition features an equally impressive range of young and talented craftsmen, from woodcarvers, sculptors, architects and makers of *pietra dure*. What may have contributed to this surge? How can we nurture this emerging enthusiasm for protecting our architectural legacy? How can we support and celebrate these time-honoured craft-skills?

Those, like me, who grew up in Blairite Britain, remember years of boom and expansion, where our success was celebrated in glass monoliths. These impenetrable steel-framed boxes devoid of personality are undistinguishable from those in any city, in any country, anywhere in the world. Schools, theatres, museums and civic buildings followed this trend with the greatest loyalty. Steel and metal to the modernists has always been a sign of progress, obliterating beautiful but worn older buildings, rising ever higher for the 'new'. Many of my generation may have re-visited their former schools to find these 'new' buildings crumbling into decay and disrepair far more swiftly than their predecessors, see examples in Telford and Oxgangs, Edinburgh, for collapsing schools. Disposable architecture, rather than creating something of lasting interest and durability, has become the modernist mantra.

The resurgence of interest amongst millennials may be connected to a search for identity. Perhaps the revived interest in our Georgian legacy is in part a rejection of the values and 'advancements' the modern world celebrates? Science and technology continue to feed our desire for perfect immortality. We have advanced so far we have no need to consult the wisdom of the past preserved in our classical inheritance. More importantly, we no longer need to think of ourselves as part of something much bigger and greater than we are. We are no longer

stewards, but masters at the centre of our own universe. It is a universe which is becoming increasingly virtual and less dependent on our physical surroundings. It also promotes the fallacy that easier and 'hands-free' is better, as Stoddart says, and banishes hard-work to the barbaric past. Such thinking has helped to slowly dismantle the relationship with our nationally inherited architecture, crafts, skills and culture.

The foundation of the Young Georgians in the 1980s was provoked by fears of stagnation and a grumbling scepticism towards modernism. This sub-group of the Georgian Group was instituted by architectural historian, John Martin Robinson, curator of this exhibition. Robinson was the architectural facade of the 'Young Fogey' movement in the 1980s, and whilst collective appreciation has improved, his campaign is as relevant today as it was thirty years ago; likewise are the films made by poet and early Georgian Group member, John Betjeman in the '60s and '70s. His cutting remarks about disfiguring modern architecture in documentaries such as, *A Poet Goes North* and *The Architecture of Bath*, available freely on the internet, still carry their full sting.

As illustrated in Hugh Petter's essay, the search for the handmade object is an increasing trend amongst younger generations. What might be the reasons for this? Certainly, the widespread consumption of luxury goods made by large scale manufacturers has played its part. Perhaps it is no longer passable to just have the latest gadget, but it must be personalised, unique and connoisseurial in some way. It must now be some way unique to that person, perhaps as an attempt to seek the human in the technology. Is it an effect of mass consumerism that the search for the truly unique has re-ignited the interest in the handmade?

With the financial crisis of 2008 we cascaded into recession. The shiny monuments to ego lay empty and forlorn. We had reached the glass ceiling. One could propose that in the shards of our economy, and with time to reflect, we searched for meaning.

The rise in popularity of *make do and mend* bore a new generation of makers. A rise of interest in crafts, not to mention the home-related crafts such as baking and brewing, has expanded dramatically over the past few years. Increasing numbers of people with a desire to work with their hands, making items for aesthetic or digestive consumption, plays a part in the wider appreciation for those skills refined and perfected elsewhere.

Interestingly, this is not only confined to the young, but to those who have sought changes in direction later on in life. Several craftsmen exhibiting have re-trained, or pursued a life of craft after working in various modern professions. For some the thrill and fascination comes from rediscovering lost historic materials and methods of production. For others it is following in the footsteps of previous craftsmen, and continuing a living tradition rather than being driven by profit alone.

The younger generation face certain obstacles. It will be harder for the next generation to become homeowners. The rise of house prices, due in part to the pressures of globalisation and the age of the Baby-Boomer generation, has increased the general strain on the individual to be eligible for mortgages. However, the burden of responsibility and duty of care should be shared collectively.

Sowing the seed of awareness for our shared historic architectural environment is important. In doing so, we will encourage a care and responsibility which transcends personal ownership. Encouraging the younger generation to form an opinion, informed by a sound respect for our inherited historic environment, is vital. This dissolves the wilful indifference which has led to some of the most destructive and

jarring developments in public architecture in recent decades. An active participation, in which younger generations take part, is necessary to ensure the Group can remain steadfast when encountering the varying obstacles of the future.

It is possible that the individual may not personally be able afford to lavish their homes with plasterwork, silks and furniture. However, they should be encouraged to stand up for and support the ideals and intrinsic value embodied within historic buildings and our shared historic environment. This is not only bound to survivals from the Georgian period, but, also creating modern buildings of lasting interest and architectural merit. As Christopher Boyle's essay points out, when craft and splendour combine the results are welcome, well-being, good repute and praise. The Old Library of Trinity College Dublin, with its majestic carving and classical decoration, will long outlive the multitude of cold glass boxes erected in recent decades by the many universities of the British Isles. There might be some truth in the saying 'you never regret your extravagances, only your economies.'

Unlike their forebears, millennials have many exciting ways to engage with likeminded enthusiasts. Indeed, in the age of Twitter and Instagram, social media allows young people to discover and explore our architectural legacy in a whole new way. Hundreds of accounts dedicated to capturing

British architecture and its details engage thousands active followers and contributors. The architects in this exhibition, for example, have a staggering combined following of over 60,000 people, a number which eclipses the four thousand members of the Georgian Group. The growing enthusiasm of such followings has created groups of loyal 'followers' who are actively seeking out the beautiful and bizarre parts of our cities, towns, villages and countryside with which to share immediately through a virtual world around the globe. Social media used in this way can harness the principle of collective ownership, rather than reducing it to the individual campaigner. It should never completely stand in for architecture, but can be another wonderful tool in raising awareness. A personal favourite of mine, a facebook group dedicated to 'Architectural Crimes', is a virtual hall of shame and has a following in the hundreds. It is essential that these virtual participants are converted into living advocates, and time will tell if this new generation of admirers materialises.

Another encouraging signal is the growing fascination for 'historical' television drama, and this cannot be underestimated. Hundreds of thousands, even millions, regularly tune into escape into splendorous interiors and worlds from history. They often do so from their own stark modernist homes, muttering how difficult it would be to polish the silver or dust the chandeliers. May this escapism point towards a deeper yearning for a connection to the past and the architecture that it was housed in? Can television be used to harness a broadened and active interest in conservation?

As a guide lecturer in one of London's most exquisite museums of ancestral European art, I regularly give tours and talks to young audiences who are increasingly attending the free and accessible evening events held in Manchester Square. Topics related to television dramas, and the misconceptions inspired by them, often lead the one-to-one questions and conversations. Curiosity at any level is always welcome and should be encouraged. Television can be the perfect way to introduce someone to studying the past, or visiting a historic house or building. They will no doubt find that the search for objective historical truths are infinitely more thrilling and relevant than the world of pure fantasy. Crucially, how does one convert these budding admirers to fully fledged advocates and promoters of traditional art and craft-skills? Transferring and developing the duty of care from the individual to the wider population will sustain the future of conservators. It undoubtedly has tremendous potential which deserves to be realised and activated.

However, the increasing popularity for topics which represent the history of health and safety, rather than the more important aspects of the progress of civilisation is lamentable. Must history and art programmes be presented by someone in a leather jacket to make it 'relevant'?

The outcry from both young and old at the dropping of A-Level Art History is also certainly a step in the right direction. Work is still required to enshrine and promote the many virtues of studying this subject in the post-internet globalised world. However, academic study must be part of a wider educational awakening. The continued hard work and support of institutions and craft colleges, such as the Prince's Foundation for Building Community, the City and Guilds London Art School and the Building Crafts College, is equally as important.

Regardless, the overall trend is positive. Hopefully, by supporting the young exhibitors and continuing to champion our glorious architectural legacy, we can look back from our 100th anniversary and see the great stride we have taken.

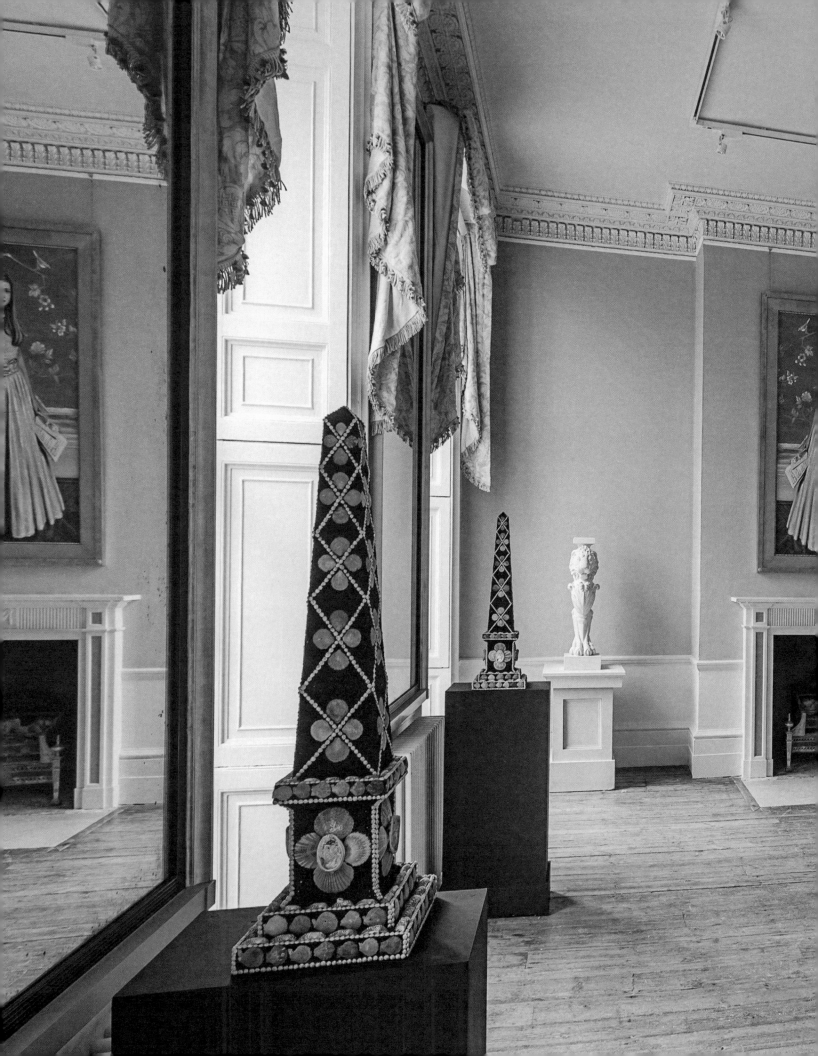

The Exhibition

The curation of this exhibition has focused on the Group's charitable objectives, exemplified by the Group's annual Architectural Awards. But the nurturing of traditional craft skills by the Georgian Group has a long history. In the 1990s a number of serious fires in important buildings had made necessary the further development and use of a burgeoning school of English craftsmen. Uppark in Sussex, a poetically unspoilt Georgian house in the ownership of the National Trust was badly damaged by fire on 30th August 1989. Under the leadership of Martin Drury, then the director general of the National Trust, it was determined to restore it, a project which took five years.

In the course of it, young students recreated the techniques of moulded stucco work and similar lost crafts. Several of them represented in this exhibition, including Trevor Proudfoot who set up Cliveden Conservation for the National Trust, and Allyson McDermott the Georgian wallpaper specialist, had been involved at Uppark. Likewise, after the fire at Windsor Castle, craftsmen like Richard Humphries, the silk weaver, and Heritage Trimmings, restored the Regency hangings while David Wilkinson rebuilt the glass chandeliers which had crashed to the ground. We are fortunate that they have lent objects to this exhibition.

When the Georgian Group decided to mark its 80th anniversary with this exhibition, I made contact with many of the friends and colleagues first encountered in those years, and have been rewarded by their enthusiasm and generosity, the fruits of which are recorded in this catalogue. I hope the wonderful photographs by Justin Paget, a colleague from Country Life, will form a permanent record of the displays and the high-quality of craftsmanship which has been maintained in England in recent decades.

John Martin Robinson, CURATOR

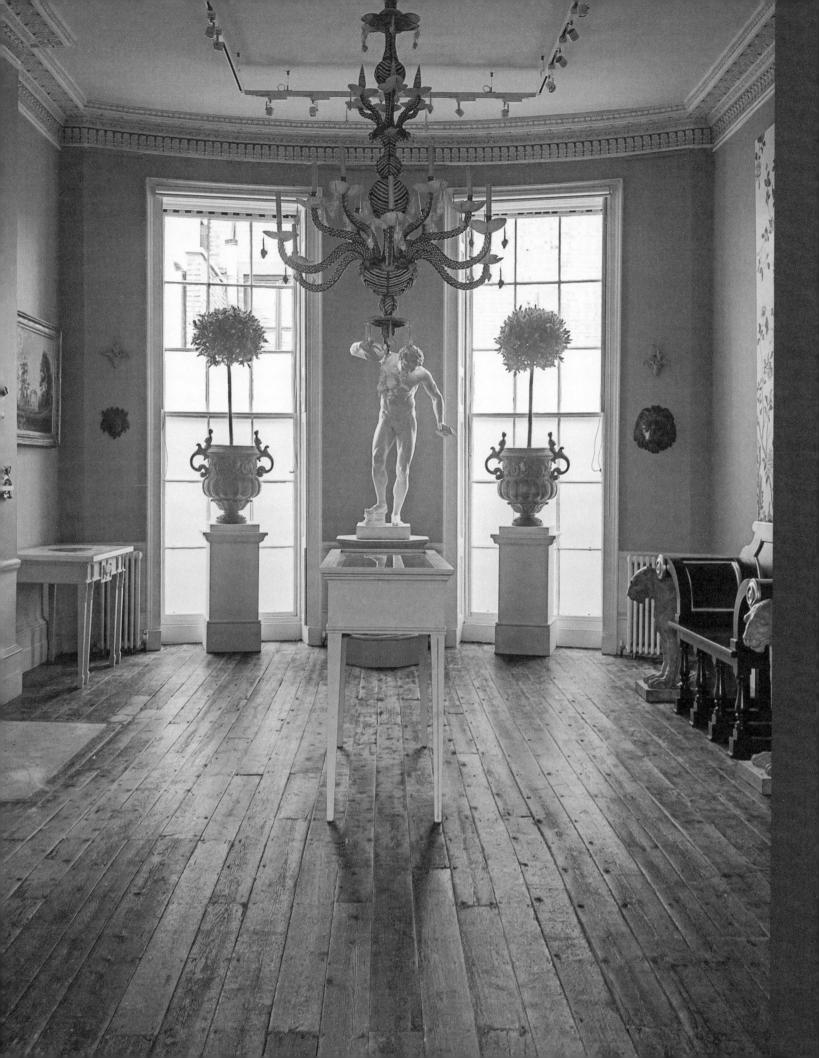

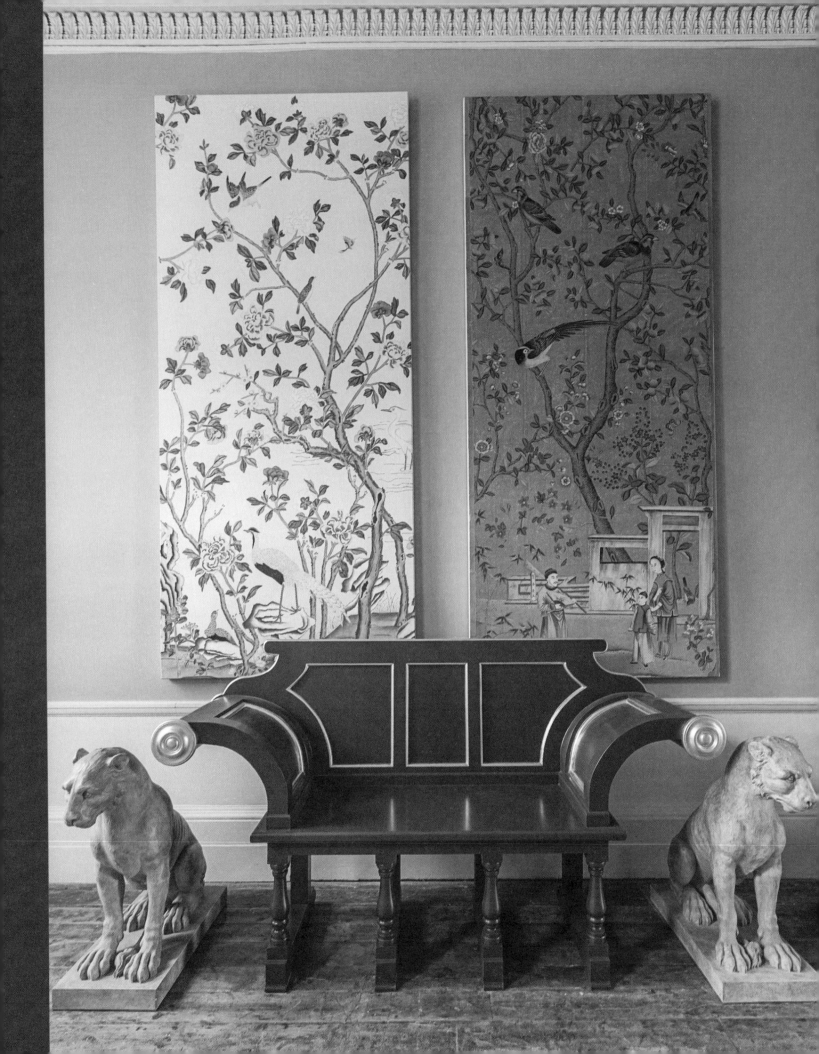

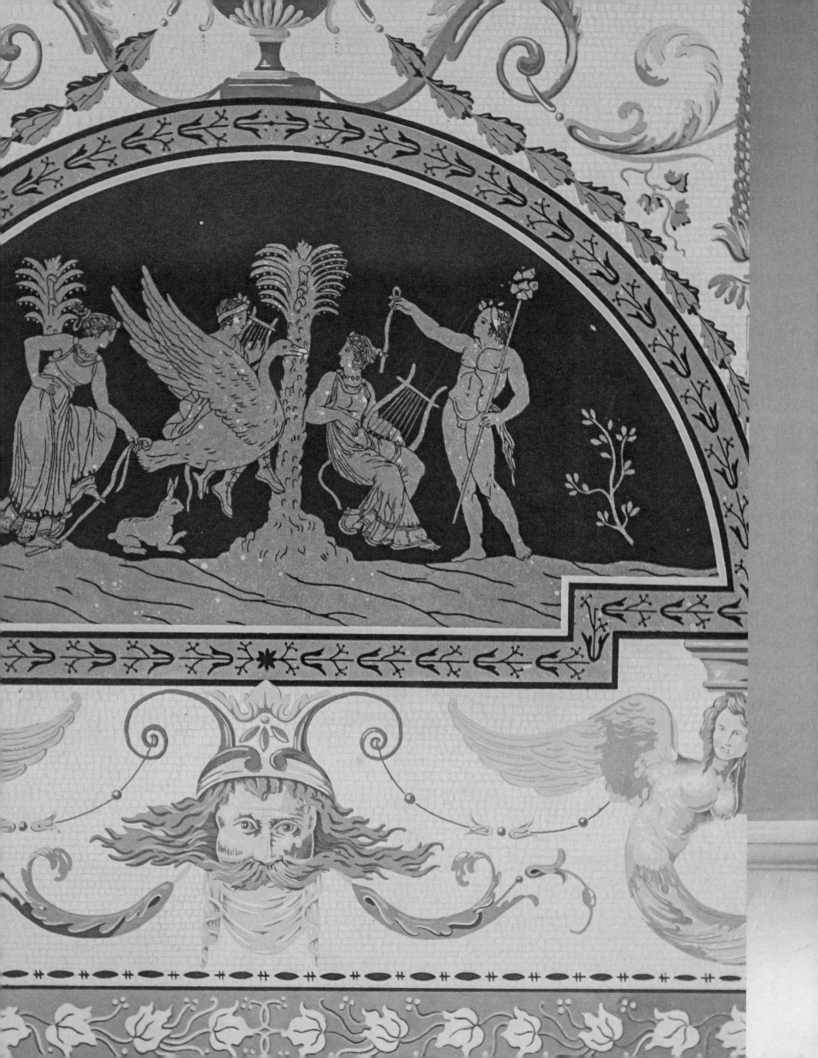

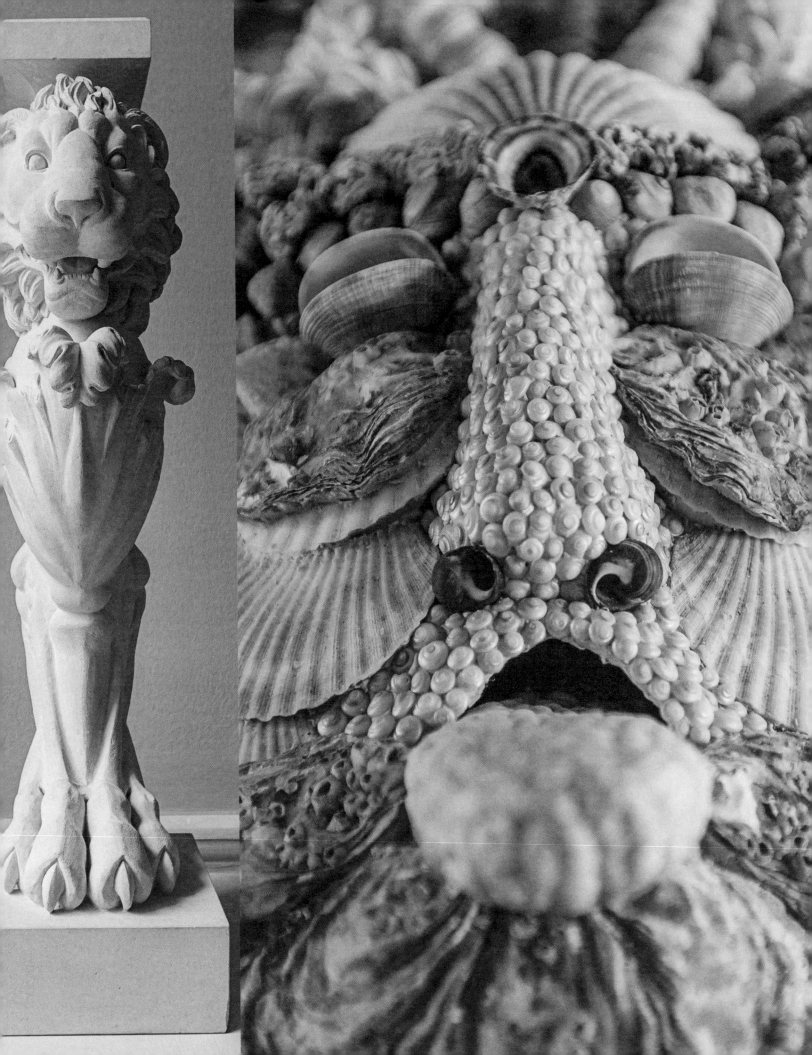

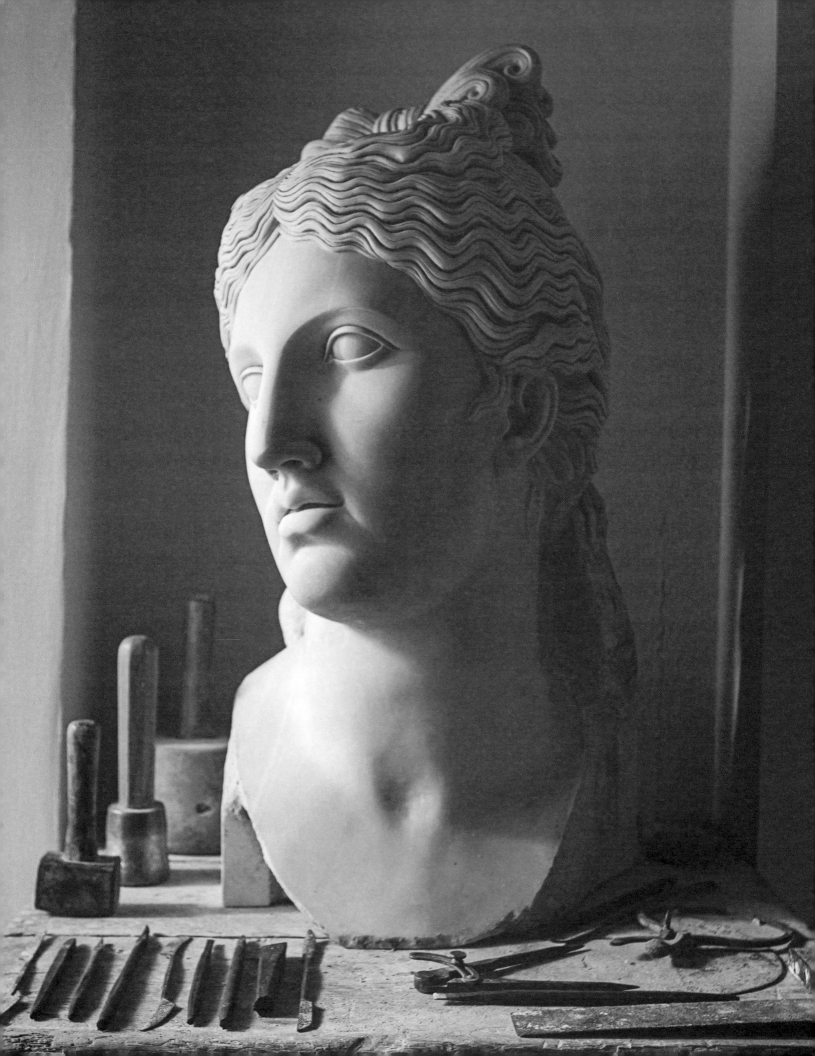

Catalogue of Exhibitors

I t is intended that the catalogue notes should illustrate the range and quality of the artefacts created by over forty artists and craftsmen. Birthdates have been included to highlight the wide spread of age and experience witnessed by the pieces. Many of the craftsmen have been involved in important restoration projects of recent decades at some of Britain's most important buildings. Traditional English craftsmen are rightly considered to be amongst the best in the world.

Indeed, a significant number of these individuals are pioneers in the rediscovery and revival of lost Georgian crafts and techniques, including hand-modelled stucco work, scagliola and Coade stone. This is not to mention fundamental construction skills, which include hand-blown crown-glass, riven lath and plaster and tuck pointing. The architects' drawings display the high level of skill and beauty made possible by working in the continuous classical tradition. All of which combines to create a panoramic snapshot of contemporary skill, thought and splendour in the Georgian tradition.

Alongside these established figures is an equally impressive range of talented and promising students, apprentices and recent graduates of craft-schools. It is these young artists and craftsmen who are carrying on these skills and traditions for future generations. Furthermore, this exhibition demonstrates that the Georgian tradition is a living tradition – that these materials, crafts and artworks are available and accessible to contemporary house-owners.

The exemplary skill and artistry that have contributed to this exhibition will enable this country to maintain, restore and embellish its great and rich collection of historic buildings for generations to come, from great churches to Georgian terrace houses. Both the discerning patron and devoted owner are enabled to look after their buildings and interiors in an appropriate and sympathetic manner.

Adam Busiakiewicz, Editor

Dimensions are given in inches and centimetres, height before width.

Corin Johnson's studio,
Camberwell, London.

Edward Bulmer

(b.1962)

Edward Bulmer Natural Paint Ltd

PEMBRIDGE, HEREFORDSHIRE

A) Georgian Group Green – Natural
 Paint

In taking a traditional approach to materials and quality, Edward Bulmer's paint is used in some of Britain's finest historic buildings. The bespoke colours for the exhibition result from his artistic and scientific approach to colour, combined with a deep and passionate knowledge of historic interior design. His advice, drawing on vast experience in both grand and modest settings, has been sought by eminent patrons in the private, public and heritage spheres.

The Georgian Group acquired No. 6 Fitzroy Square as their headquarters in 1995, and restored the building and interiors. Patrick Baty, the specialist paint analyst, researched the unique colour schemes and discovered the use of this specific green colour in the first-floor rooms. Bulmer has produced this distinctive shade for the restoration of these rooms.

The insistence on historically informed materials and techniques, and rejection of synthetic additives or enhancers, help to create a 'living finish'. In contrast to the lifeless plastic finishes of most modern paints, the natural materials in these paints will ensure their patina will age gracefully with time. Such a traditional approach not only enhances the aesthetic experience of the material, but is also part of an ethical approach to conservation and the environment.

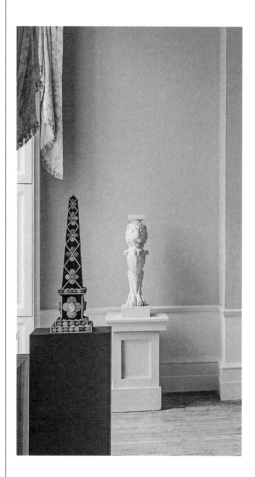

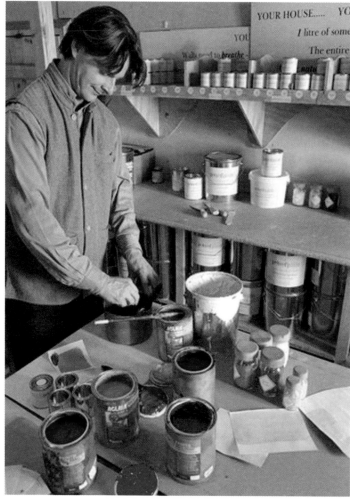

Lida Cardozo Kindersley

(b.1954)

The Cardozo Kindersley Workshop

CAMBRIDGE

A) Welcome
Letters cut in Welsh slate with
flourishes. Painted off-white
Welsh slate
20⅞ × 13 × 2¾in., 53 × 33 × 7cm.
2015, Artist's studio

B) Gilded alphabet plaque
Blue-grey slate
15⅜ × 15⅜ × ¾in., 39 × 39 × 2cm.
1997, Artist's studio

Lida Kindersley is the director of the
Cardozo Kindersley Workshop, which
specialises in the carving of inscriptions
into stone. Lida continues the company
and tradition established by her late
husband and teacher David Kindersley
(1915–1995), a former apprentice of the
British sculptor Eric Gill. They began
collaborating in 1976, and had worked
together on numerous projects such as
inscriptions for the Ruskin Museum in
Sheffield. Apart from work in stone, the
workshop also undertakes lettering for
type design, glass engraving, bookplates
and publishing.

The pieces exhibited display the wide
range and high quality of carving achieved
by Lida and her assistants and apprentices.
Following traditional methods of carving,
cutting, placing and drawing, all of these
pieces are made by hand without the
use of machines. The quality of carving
complements the inherent beauty of the
slate and stone, fusing both elements of
design and material in a timeless manner,
which descends from the Roman Empire.
In Lida's own words: 'As letter-cutters, we
must mean what we say and how we say it.
The alphabet is the most precious secret
we hand on – in stone we make it last.'

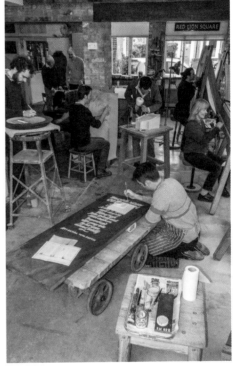

George Carter

(b.1948)

George Carter Design

NORTH ELMHAM, NORFOLK

A) Repton plant stand
 A replica of a Repton design
 Painted hardwood and metal
 13½in. × 13½in. × 5ft 0in.,
 34.3 × 34.3 × 152.4cm.
 2016, Private collection

B) Caisses de Versailles and topiary
 Painted timber and living plant
 24in. × 24in. × 5ft 0in.,
 60.96 × 60.96 × 152.4cm.
 2016, Private collection

C) Caisses de Versailles
 Painted timber and living plant
 24in. × 24in. × 5ft 0in.,
 60.96 × 60.96 × 152.4cm.
 2016, Private collection

George Carter has designed many high profile museum exhibitions for prominent clients, such as Historic Royal Palaces, and has brought his discerning aesthetic tastes to this exhibition, which has been arranged under his direction.

Carter's traditional approach is informed by his training as a sculptor. In 1985 he started to design gardens, and has since exhibited at the Chelsea Flower Show and won several RHS Gold Medals.

The three plant stands are an extension of Carter's interest in historic furniture. Notably, the Repton stand is inspired by the garden furnishings of the late

Georgian English landscape gardener Humphry Repton. The other plant containers are inspired by pieces which were originally crafted for Le Nôtre's gardens at Versailles.

Carter also designs a variety of small and large-scale garden furniture inspired by historic gardens, including seating, gates, wooden pavilions, obelisks and pyramids.

Philip Cath

(b.1973)

English Portraiture

BLACKHEATH, LONDON

A) *Miss Faith Waddell as Splendour*
Oil on linen
72 × 40in., 182.2 × 101.6cm.
2016, Artist's studio

B) *Portrait of the Collins Sisters*
Oil on linen
60 × 36in., 152.4 × 91.4cm.
2016, Private collection

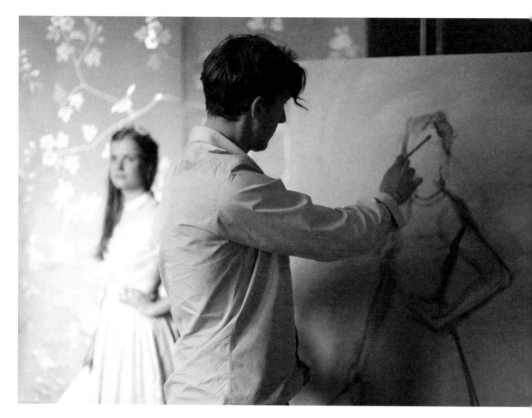

After reading History at Oxford, Cath completed his Masters of Fine Art at Goldsmiths University. His studies in draughtsmanship were supplemented by his attendance at the Prince of Wales's Drawing School in Shoreditch, an organisation established in 2000 to teach and promote the ancestral methods of drawing from observation.

For the painting, *Miss Faith Waddell as Splendour*, painted at the request of the Chairman specially for this exhibition, Philip has cast Faith as the personification of 'Splendour', one of The Three Graces from Greek mythology. The painting not only celebrates the exhibition itself, which is referenced by the flyer she holds in her hand, but also her membership of The Young Georgians, which represents the bright future of The Georgian Group. The full length portrait was painted over the course of approximately ten sessions at the studio in Blackheath.

As a portrait artist, Cath claims his skills are self-taught. Despite this modesty, his skill for capturing a likeness is combined with a deep appreciation for and fascination with traditional painting methods, including on insisting from working from life. Although he tackles portraits in any format, he excels in the full-length, arguably the most taxing and consuming of all canvas sizes for any artist.

In his own words: 'As I matured as a painter, I became in turn a student of the great English portrait tradition, which to my mind encompasses everything from from Van Dyck to Orpen. I admire paintings of all kinds, modern and historic, but still nothing captivates me like a good portrait, that is one which has a 'breathing likeness'. A good portrait is something you can develop a relationship with over time – and that's regardless of whether it was painted yesterday or over four hundred years ago.'

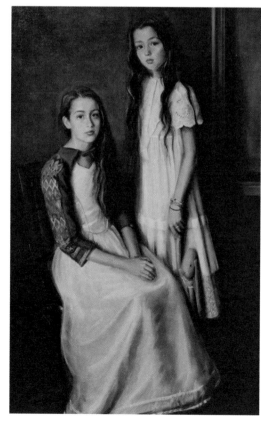

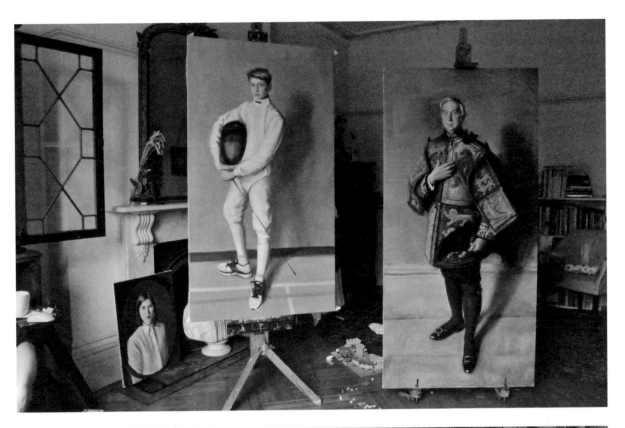

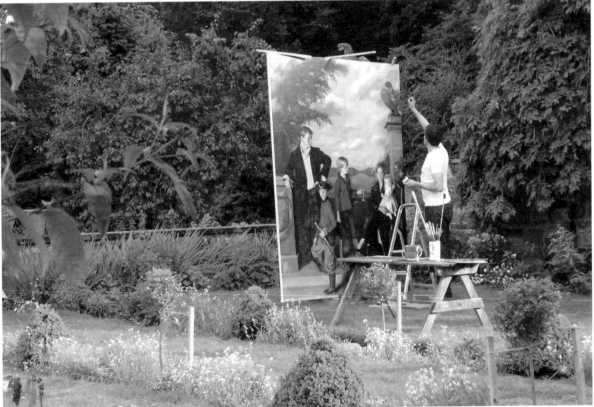

Collier Webb Foundry

EASTBOURNE, EAST SUSSEX

A) Four brass curtain tiebacks

B) Brass chains and hooks for pictures

The Collier Webb foundry continue a tradition which was begun over thirty five years ago by the late Cedric Collier, who began casting as a hobby and set up his business producing handles for the antiques trade. The present owners begun their enterprise in 2011, and have continued to expand their enterprise into many different forms and areas of metal casting and design. The foundry now produces high quality castings in brass, bronze, aluminium and silver, using lost wax and sand casting processes.

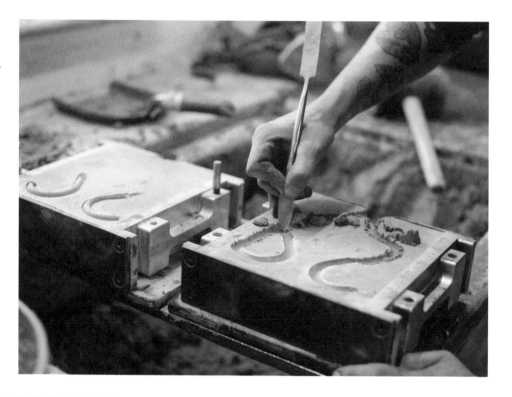

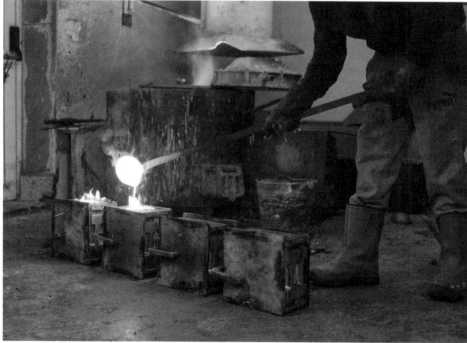

Chichester Stoneworks

Emma Sheridan, Alex Waddell, Joe Milne,
Andrew Smith, Will Lovell
Design: Russell Taylor Architects
CHICHESTER AND LONDON

A) Chimneypiece
Portland Stone
43⅞in. × 54½ × 6in.,
139 × 111.5 × 15cm.
2016, Georgian Group

Chichester Stoneworks is one of the leading stonemasonry companies in Great Britain, and executed restoration work on several of the Royal Palaces, including work at Buckingham Palace. Aside from restoration work, they take on new commissions for work in stone, including architectural features, porticoes and chimney pieces with a strong emphasis on being sympathetic to their intended environment.

The neo-classical fireplace, based on the missing original, has been specifically commissioned by the Georgian Group as part of a long-term programme of restoration of No. 6 Fitzroy Square.

It has been carved by the apprentices of Chichester Stoneworks (listed above), with the support of and sponsorship by the Worshipful Company of Masons as part of their practical training in the craft of masonry. It was designed by Russell Taylor Architects, specialists in designing in the classical tradition, based on an original which survives in a contemporary neighbouring building on Fitzroy Square. The Portland Stone, one of the finest architectural materials used widely in the Georgian period, was given by Albion Stone.

Cliveden Conservation

Founded 1982
MAIDENHEAD, BERKSHIRE

A) The *Dancing Faun*
 Plaster cast
 57⅞ × 32¼ × 22in., 147 × 82 × 56cm.
 2016, Private collection

B) Bust of *Horace*
 Plaster cast
 26 × 18⅞ × 11⅜in, 66 × 48 × 29cm.
 2016, Private collection

C) Bust of muse
 Plaster cast
 25⅝ × 15⅜ × 9½in., 65 × 39 × 24cm.
 2016, Artist's collection

D) *Aphrodite* after Roman original,
 for a replica statue for the Duke of
 Northumberland
 Plaster cast
 98 × 48in., 250 × 120cm.
 Private collection

Trevor Proudfoot is director of Cliveden Conservation, which was founded in 1982 for the preservation of buildings and statuary of the National Trust. His son Lewis joined Cliveden in 2009, and during 2012–13 undertook studies in Heritage Masonry at the Prince's Foundation. The company took a leading role in the conservation of the fire-damaged rooms of Uppark during the early 1990s. More recently, their work at the Gothic Tower at Wimpole, Cambridgeshire, won the 2016 Georgian Group Architectural Award for the Restoration of a Structure in a Landscape.

Both busts are copies of originals by Henry Cheere. The female muse was reconstructed from broken fragments rescued from the ashes at Claydon.

The Horace bust is a copy of an original from the Pantheon at Stourhead.

The figure of Aphrodite is a recreation of an original Roman statue once owned by Robert Adam, then acquired by the 1st Duke of Northumberland in 1773 for the Hall at Syon, where it was until its sale in 2014.

Since 1990, Trevor Proudfoot has been working with the National Trust to recreate the historic sculptures at Stowe both in plaster and from a mixture of artificial stone. The *Dancing Faun* is a copy of an original piece from Kedleston, which was recreated for Stowe. Following the eighteenth-century tradition of copying sculptures by using moulds, this method allows for the successful recreation of historic sculptural schemes that have since been dispersed or suffered damage or decay.

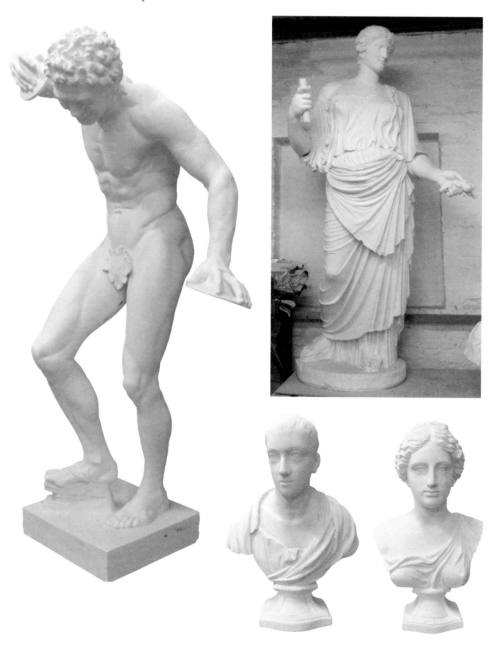

The Marquess of Cholmondeley

(b.1960)

The Houghton Furniture Company

King's Lynn, Norfolk

A) Kent seat
 Hardwood seat painted with gold trim
 44⅞ × 78⁶⁄₈ × 24¾in.,
 114 × 200 × 63cm.
 2016, Private collection

This bench is based on a pair which survive at Houghton Hall, Norfolk, originally built for Sir Robert Walpole in the early eighteenth century. The design of the bench is attributed to architect William Kent, and may have been completed around the time the Palladian mansion was first built. The strong architectural features and form complement and enhance the grand setting for which this bench was designed.

The Houghton Furniture Company, a part of the Estate of Houghton Hall owned by Lord Cholmondeley, produces faithful replicas of original furniture at Houghton. Traditional methods of construction, decoration and finish enhance the elegant eighteenth-century design found in each individual table, chair, cabinet or mirror. All pieces are supervised by John Ives, a skilled cabinet maker based in Skipton, Yorkshire.

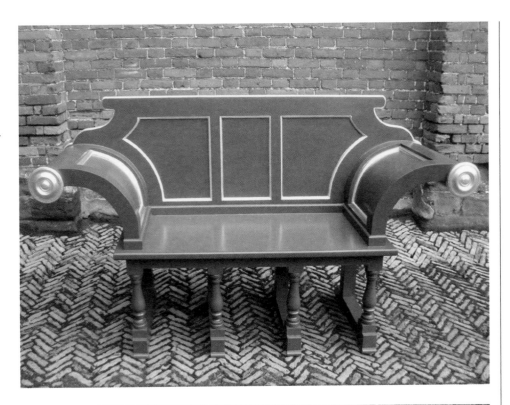

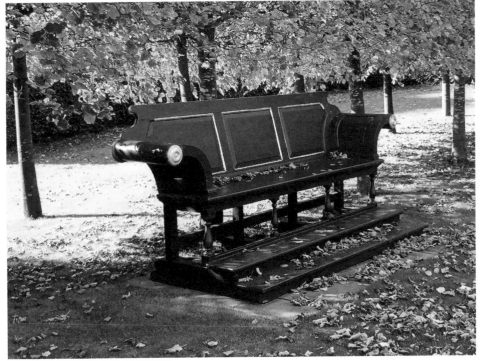

Matthew Collins & Mathew Bray

(b.1976, 1977)

Mathew Bray & Matthew Collins Ltd

LONDON & SOMERSET

A) Pier glass in ebonised and gilded frame
Glass, timber
112¼ × 44½ × 2¼in.,
285 × 113 × 5.6cm.
2016, Artist's studio

B) Pier glass
Glass, timber
112¼ × 44½ × 2¼in.,
285 × 113 × 5.6cm.
2016, Artist's studio

C) Mahogany '*faux bois*' sample panel
Timber and paint
17¾ × 23⅝ × ¾in., 45 × 60 × 2cm.
2016, Artist's studio

D) Sienna '*faux marbre*' sample panel
Timber and paint
15¾ × 23⅝ × ¾in., 40 × 60 × 2cm.
2016, Artist's studio

The two pier glasses were made specifically for the front first floor room of No. 6 Fitzroy Square and reflect the 1790s architraves of the room. The ebonised and gilded treatment reflects late eighteenth century and Regency fashion, and were hand silvered to add greater subtlety to the surface.

Mathew Bray & Matthew Collins Ltd specialise in a wide variety of different furniture, materials and historic finishes. Mathew and Matthew met as young boys, and their friendship brought them together during their work in architectural restoration whilst still at University, before going on to establish their decorative arts studio.

Apart from the pier glasses, they specialise in creating wall papers and coverings, finished by hand using traditional woodblocks, stencils and hand painted formats. The company, which work out of studios in both London and Somerset, take a connoisseurial approach to decorative finishes and the production of furniture. The breadth of techniques and materials employed by the company represents their ambitious mutli-disciplinary approach to the decorative arts.

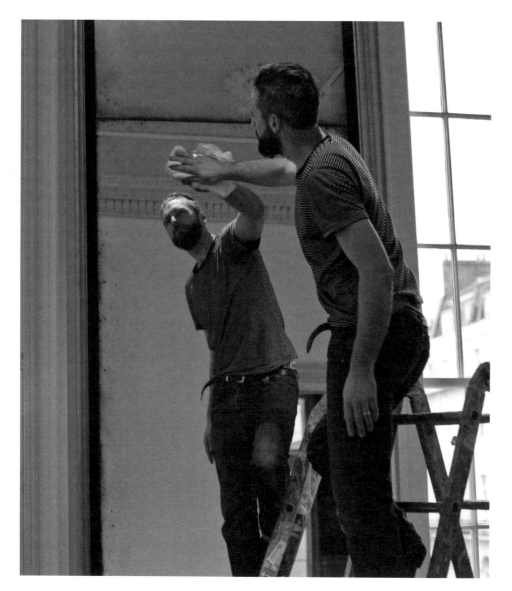

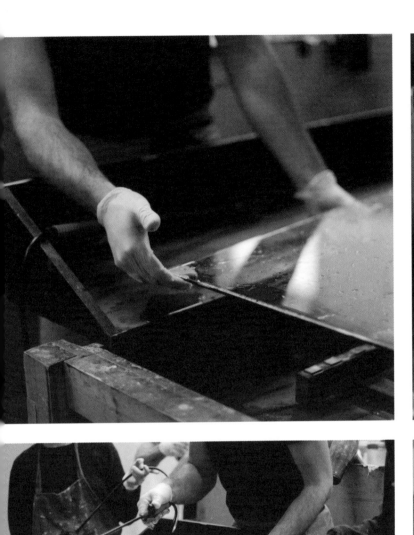
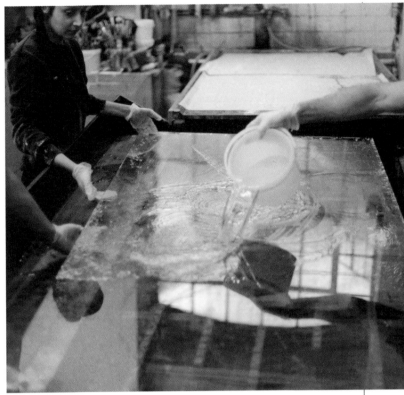
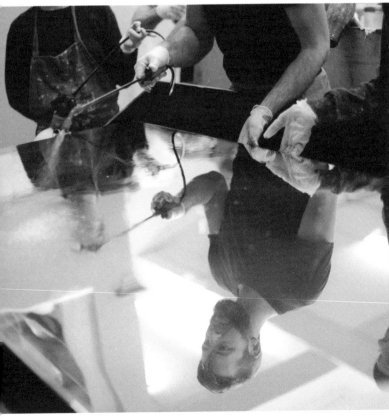

Alexander Creswell

(b.1957)

LONDON

A) Study for a Baroque ceiling
 Watercolour
 38 × 60in., 96.52 × 152.4cm.
 2014, Artist's collection

Alexander Creswell is best known for his paintings for the Royal Collection, especially the series of watercolours that illustrate the destruction and restoration of Windsor Castle after fire damage in the early 1990s. Born in Helsinki, Finland, Creswell was educated in England, including the Byam Shaw School of Art, London and West Surrey College of Art and Design, Farnham. The strong architectural elements observed in his work were enriched during his time spent as a tutor at The Prince of Wales's Institute of Architecture between 1991 and 1999.

This watercolour study is for a full-size baroque ceiling commissioned by a private patron. It takes inspiration Andrea dal Pozzo's remarkable ceiling for the Church of St Ignatius, Rome, completed in the late seventeenth century, and admired by countless Georgian Grand Tourists. Despite being a largely self-taught watercolourist, Creswell enjoys using this medium on a tremendously large scale, from which these smaller studies act as an opportunity to experiment with form, design and colouring.

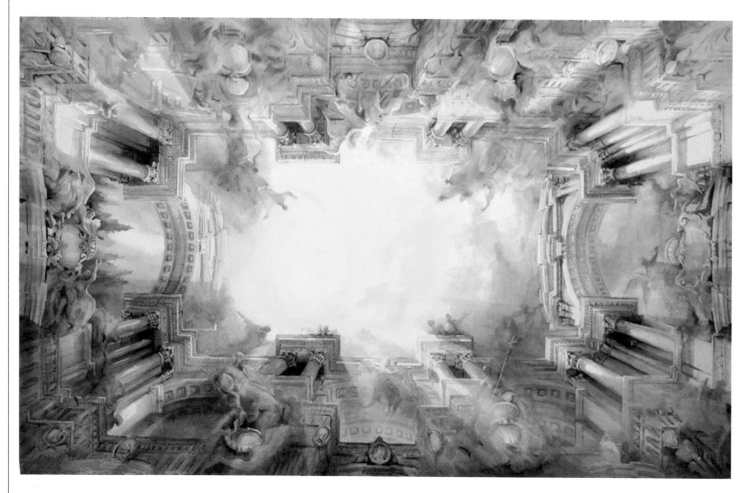

Alan Dodd

(b.1942)

ISLINGTON, LONDON

A) Baroque overdoor panel with Kentian
mask and oak swags
Oil on plywood
39⅜ × 91¾in., 100 × 233cm.
1996, Artist's collection

B) Neo-classical overdoor panel
Oil on plywood
39⅜ × 64⅝in., 100 × 164cm.
1996, Artist's collection

C) Fonthill Abbey, from the south-west
Oil on wood prepared with gesso
35 × 43⅜in., 89 × 110cm.
1976–79, Artist's collection

D) The Tower of the Winds, Athens
Oil on gessoed card
9⅛ × 5⅞in., 24 × 15cm.
1994, Artist's collection

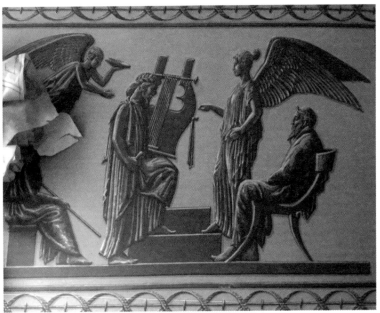

A versatile mural painter, Alan Dodd
has painted many historically inspired,
new, as well as restored schemes for
both public institutions and private
individuals. Trained at Maidstone College
of Art (David Hockney was one of his
teachers) and later the Royal Academy
Schools, Dodd has worked on recreated
decorative schemes at Spencer House, Sir
John Soane's Museum, the Victoria and
Albert Museum and the National Gallery.
His ability to paint original and historic
schemes in a variety of different historic
styles, including baroque, neo-classical
and neo-gothic, is a testament to his vast
knowledge of historic interiors.

The overdoors were painted specifically
for the Georgian Group and display
Dodd's versatility as decorative painter.
In contrast, the views of Fonthill Abbey
and the Tower of the Winds show
the artist's fascination for painting
architecture, many of which were
executed during travels in Britain and on
the continent.

Clunie Fretton

(b.1989)

NEWTON VALENCE, HAMPSHIRE

A) Three designs for the Phillimore
coat of arms
Pencil on paper
23⅜ × 16½in., 59.4 × 42cm. (2)
16½ × 11¾in., 42 × 29.7cm. (1)
2016, Artist's collection

B) Acanthus leaf
Lime wood, gesso
4¾ × 11½ × 3½in.,
120 × 290 × 90mm.
2016, Private collection

C) Cartouche
Lime wood
7⅛ × 8½ × 3⅜in.,
180 × 220 × 85mm.
Artist's collection

Clunie Fretton graduated in 2015 from the
City & Guilds of London Art School with
a diploma in Ornamental Woodcarving
and Gilding, and has since served as the
Carving Fellow for the year 2015–16.
She has worked for a variety of patrons
and institutions, including at St George's
Chapel, Windsor, the Worshipful
Company of Fishmongers, the Joiner's
& Ceilers Company and the Mercers'
Company.

Fretton was drawn to carving at an early
age, explaining that 'It demands a degree
of rigorousness that always appealed to
me, but initially it was seeing the quality
of practising carvers' drawings that made
me most interested in the craft. I enjoyed
the precision and sensitivity they showed,
which fed into the things they modelled
and carved, and that in turn inspired me
to learn.'

The richly-decorated coat of arms
was carved for Lord Phillimore, Prime

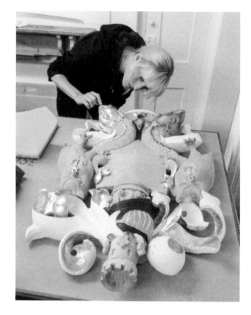

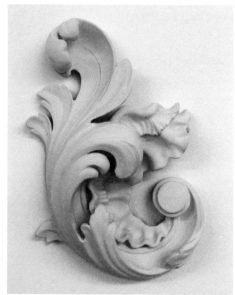

Warden of the Fishmonger's Company,
son of architect and early Georgian Group
member and supporter Claud Phillimore
(1911–94).

Kevin Gannon

(b.1966)

Farthing and Gannon

NEWNHAM, DAVENTRY

A) A pair of Siena scagliola pedestal
 columns
 Scagliola
 49⅛in. height × 13⅜in. diameter,
 125 × 34cm.
 2016, Artist's studio

Farthing and Gannon, established in 1989,
are restorers and makers of scagliola and
fine plasterwork. They have been involved
in the restoration of several historic
buildings, including works for the Historic
Royal Palaces, Somerset House and the
Royal Courts of Justice.

Scagliola, which consists of various
colours mixed in with plaster and gypsum,
was often used for pedestals and columns
in important buildings throughout the
Georgian period. The impressive skill for
colouring and texture shown by craftsmen
working in scagliola meant that highly
polished stones and rare marbles could be
imitated and replicated in this versatile
material. Apart from pedestals, scagliola
was widely used to create table-tops and
ornate floors decorated with various inlay
work.

These particular columns imitate Siena
marble, a luminous and decadent yellow
material quarried in Italy and particularly
favoured in the Georgian period, often in
combination with white marble, stone or
plaster.

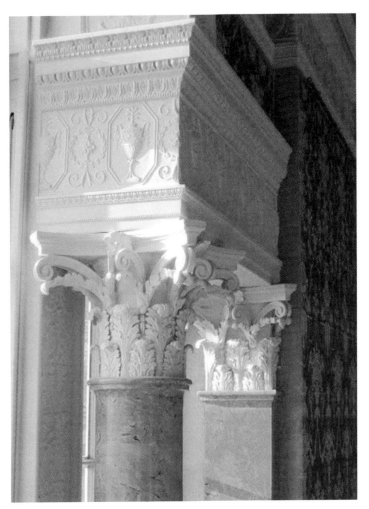

George Jackson Limited

Established 1780

SUTTON, SURREY

A) Section of neo-classical cornic.

B) Section of classical modillion cornice

C) Section of classical dentil cornice

D) Section of egg and dart cornice

E) Classical swag, 20⅞ × 6½in.,
53 × 16.5cm.

F) Console bracket, 12¼ × 14⅛in.,
31 × 36cm.

G) Classical cornice bracket, 6½ × 7⅝in.,
16.5 × 19.5cm.

H) Plaster plaque featuring still life
of fish, flowers and various plants
suspended on a decorative ribbon
Diameter 27⅛in., 69cm.

I) Ionic capital. Diameter 7¼in., 18.5cm.

J) Corinthian capital
Diameter 14⅛in., 36cm.

K) Doric capital

L) Guilloche moulding, based on
William Kent's designs for Holkham

M) Guilloche band moulding

N) Vitruvian scroll moulding

O) Samples of historic boxwood moulds

Founded in 1780, George Jackson Ltd lays claim to the greatest lineage of historic plaster-craftsmanship in the country. Originally based a stone's throw away from Oxford Circus, the company has supplied plasterwork to many of London's historic buildings. Their current premises in Sutton, Surrey, houses their collection 11,000 boxwood moulds. Some of these date back to Robert Adam, and additional moulds have been created over the years based on surviving architectural details found in historic houses throughout Great Britain.

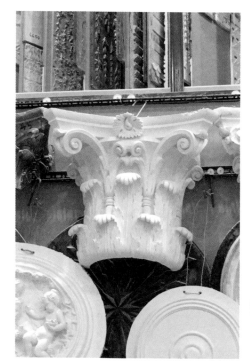

The range of pieces on display reflect the high quality of finish made possible using traditional methods perfected by generations of inherited and informed craftsmanship. The crisp architectural pieces, such as the decorative plaque, convey the high level of artistry that can be achieved by adhering to Georgian principles of quality design and execution using moulds.

Jackson's plasterwork can be found in some of Britain's most historic buildings, including in the restored State Apartments at Windsor Castle and Hampton Court Palace. Their involvement in the recreation of damaged rooms of Uppark, West Sussex, after the fire in 1989 earned the company the Plaisterer's Trophy and Humber Silver Salver Award in 1999.

Sarah Goss

(b.1986)

Sarah Goss Traditional
Woodcarving & Restoration

MIDHURST, WEST SUSSEX

A) Acanthus leaf
Limewood
7⅞in. × 4¾in. × 2⅝in.,
20 × 12 × 6.5cm.
2016, Artist's studio

B) Mirror side leaves
Pine
20½ × 1⅝ × 1in., 52 × 4 × 2.5cm.
2015, Artist's studio

C) Acanthus corbel
Limewood
17¾ × 4⅛ × 6⅛in.,
45 × 10.5 × 15.5cm.
2008, Artist's studio

D) Acanthus decorative plaque
Limewood
11⅞ × 7⅞ × 1in., 30 × 20 × 2.5cm.
2016, Artist's studio

E) Mirror crests in the style of
Chippendale
Pine
10 × 8⅞ × 2⅜in., 25.5 × 22.5 × 6cm.
2015, Artist's studio

F) A pair of carved bird plaques
Limewood
7⅞ × 11⅞in., 200 × 300mm. (2)
2014, Artist's collection

Sarah Goss's interest in the arts
began during her studies at school in
Buckinghamshire, where she completed
A-Levels in both Art and Art History.
Her immersion in craft continued at
Portsmouth University, where she
undertook a degree in Restoration and
Decorative Studies, which concluded in
2008. During her studies at Portsmouth
she was able to indulge her interest in
woodcarving and plasterwork, with ample
time and opportunity to experiment with
designing and working with traditional
hand-modelled stuccowork and plaster.
She established her own woodcarving
practice in 2009, specialising in creating
and restoring works of art using traditional
techniques and materials.

In her own words: 'Woodcarving is
incredibly versatile and therefore remains
full of new challenges. … I also love the
fact that I work using tools and techniques
that haven't changed through generations
of woodcarvers.'

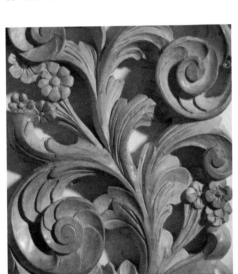

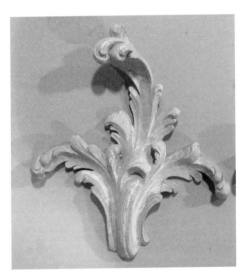

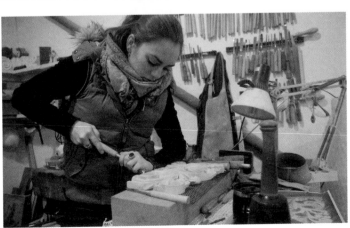

de Gournay

(Established 1986)

CHELSEA, LONDON

A) Chinoiserie painted panel after original wallpaper in the dining room at Abbotsford House, Scotland
Printed and hand-painted decoration on Ice Blue India tea paper
120 × 48in., 304.8 × 122cm.
2012, Company collection

B) Chinoiserie painted panel after original at Temple Newsam, Leeds
Printed and hand-painted decoration on blue-green dyed silk
120 × 36in., 304.8 × 91.5cm.
2004, Company collection

C) Chinoiserie painted panel after original at Woburn Abbey
Printed and hand-painted decoration on white-painted Xuan paper
141¾ × 48in., 360 × 122cm.
2015, Company collection

Paper and silk wall hangings embellished with painted decoration were popular during the Georgian period. The decoration in these panels reflect the contemporary fashion for chinoiserie, inspired directly by Chinese and Korean design, which often features a dizzying array of colourful and vibrant exotic birds, animals and fauna.

De Gournay was founded by Claud Cecil de Gurney in the mid-1980s. His interest in craft began due to a fascination for Chinese art and history in his childhood, despite beginning his professional career as a chartered accountant. The company has since become renowned for its revival of hand-crafted wallpapers. Most paper hangings crafted by the company's skilled artists begin with block printing, with extra flourishes and details being added by hand afterwards in the traditional manner.

The Woburn paper was re-created by de Gournay from fragments of original wallpaper discovered in the 4th Duke of Bedford's bedroom in Woburn Abbey. The other two panels are based on original surviving wallpapers found in Temple Newsam and novelist Sir Walter Scott's home, Abbotsford House. The Abbotsford examples, still in situ, were a gift to Sir Walter from his cousin Hugh Scott, the captain of a ship in the East India Company, in 1822.

Thomas Greenaway
(b.1985)

Greenaway Mosaics LLP

Based in Towcester,
Northamptonshire

A) Games table with *pietra dura* top
English walnut and burr walnut
veneer with rotating *pietra dura* chess
and backgammon playing surface
28¾ × 32⅝ × 32⅝in., 73 × 83 × 83cm.
2012, Private collection, Norfolk

Inspired by visits made to Florentine
museums a mere twelve years ago,
Thomas Greenaway has become one of the
most promising British craftsmen working
with polished hardstones. Although his
training started in the art of wooden
marquetry, his interest in reviving and
working with the painterly effects of *pietra
dura* was encouraged by his apprenticeship
in several eminent workshops in
Florence. After returning to Britain in
2007, Greenaway established his own
workshops, where he produces an array of
panels, boxes, tables and other artworks.

The arrangement of the central chess
board in the games table perpetuates the
Georgian fascination with rare and prized
polished stones. Very much in the taste of
eighteenth- and early-nineteenth century
antiquarianism, this piece contains a
dazzling array of purple fluorite, deep red
and green porphyry, striped jasper and
various other marbles.

Alongside his secular work for
private patrons, Thomas's most notable
commission to date includes the coat
of arms for the tomb of Richard III in
Leicester Cathedral.

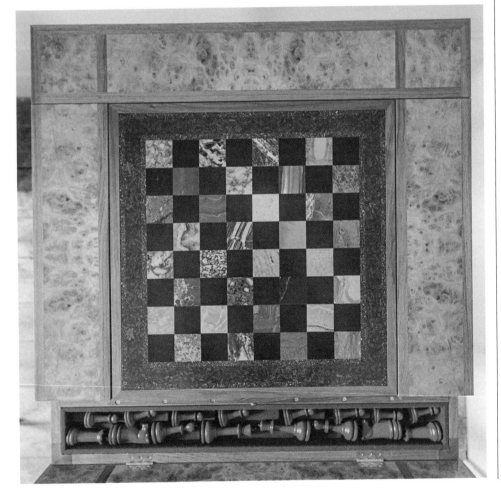

Anthony Gregg

(b.1973)

Fine Frame Conservation

HAMMERSMITH, LONDON

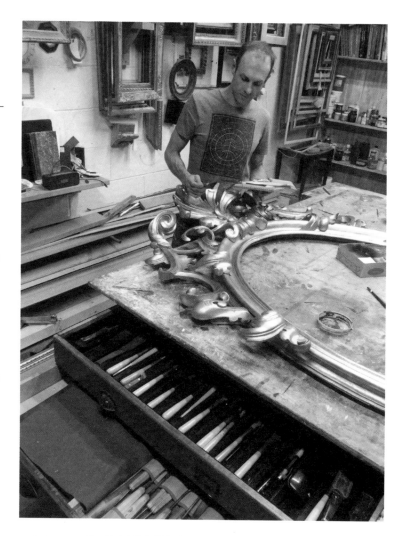

A) A pair of hand-carved and gilded
 William Kent portrait frames
 Gilded lime wood and pine
 59 × 47¼in., 150 × 120cm. (2)
 2016, Arundel Castle, West Sussex

Anthony Gregg came to London in 2000
to work for a well-known dealer of historic
portraiture, a short while after completing
his studies in Fine Art in his native South
Africa. He began his career as a painter
and sculptor in wood, where he quickly
developed a keen interest in antique
frames. In 2015 he won a prestigious City
& Guilds Medal for Excellence and a Lion
award for his achievements at the London
School of Picture and Frame Restoration.

The pair of frames was commissioned
by the Duke of Norfolk for two existing
portraits by artist June Mendoza (b.1927).
Their design, which takes inspiration
from William Kent's portrait frames, was
chosen to complement the room in which
they will be hung at Arundel Castle. In his
own words, Gregg wanted 'the paintings
to be an active voice in the architectural
conversation of their setting'.

The transformative effect of traditionally
carved wooden frames, ensured by Gregg's
eye for historic detail and traditional
craftsmanship, allows them to become
artworks in their own right. His work
carving new pieces is complemented by his
experience in the conservation of historic
frames, informed by a deep respect for the
traditional methods of woodworking and
gilding.

Felix Handley

(b.1984)

HARLESDEN, LONDON

A) Lion trapezophoro
 Portland limestone
 30 × 9⅝ × 10in., 76 × 24.5 × 25.5cm.
 2016, Artist's Collection

Carved with great precision out of Portland limestone, this reproduction of a Roman trapezophoro (table support) is based on a first-century AD example from the Palazzo Doria Pamphilj in Rome.

Felix Handley received his initial training in fine art at Central Saint Martins UAL. He was attracted to a life of craftsmanship after being exposed to the traditional arts by his mother, a restorer of textiles. In 2016 he re-qualified as a carver at the City & Guilds of London Art School. During his studies at City & Guilds, where practical and traditional skills are a fundamental part of the curriculum, he was the recipient of the Brinsley Ford Award for drawing. The prize and grant allowed Handley to spend three weeks in Rome, where he made meticulously observed studies of artworks in the capital's museums and galleries. This imposing lion caryatid resulted from drawings Handley made during his sojourn in Italy. In doing so, he follows the footsteps of countless Georgian artists and sculptors of the eighteenth and nineteenth centuries, who visited in order to observe first-hand and record classical artworks in situ. Handley's studies concluded with the award of the Master Carvers Annual Prize at the City & Guilds of London Art School.

Handley works in a variety of different media, including stone, wood and plaster, and has recently completed a classical frieze adapted from a decorative doorway design. He is now involved in the restoration of historic sculpture as well as producing new works of outstanding quality.

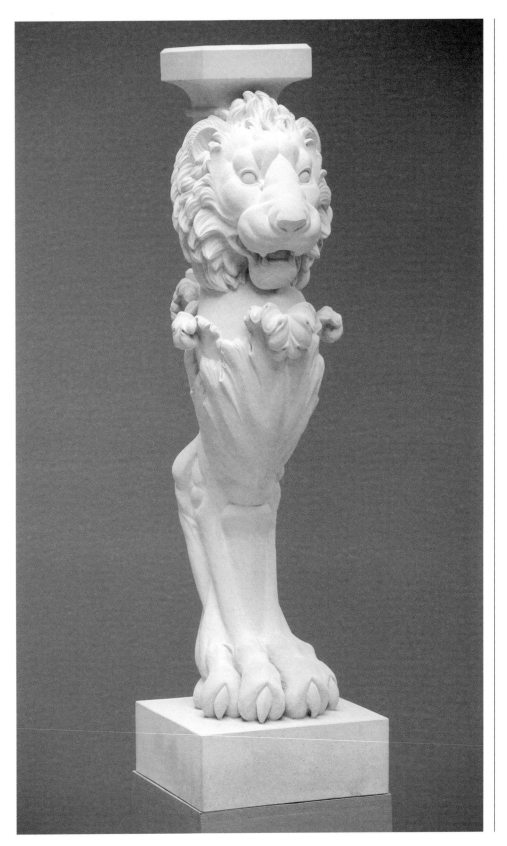

Heritage Trimmings

Founded in 1991
DERBY

A) Tassel sample with spiral, bead and flower drops.
 Tram silk, metallic thread and wood
 10in., 25.4cm long
 2017, Company collection

B) Bullion fringe with spiral, ball and flower drops.
 Silk and metallic threat
 6¼in., 15.88cm long
 2017, Company collection

C) Double soft spun cord in silk
 Silk
 2017, Company collection

Heritage Trimmings Ltd was formed in 1991 to produce gold, silver and silk passementerie for the restoration of the Kings Apartments at Hampton Court Palace. The company's founder, Nick Tubbs, began his career as a trainee textile engineer, working for a family owned company who produced trimmings for the fashion and lampshade trades. His introduction to the manufacture of passementerie began in the late 1970s, where he worked for leading producer A. Sindall Ltd. Nick continued to develop production techniques and processes, before founding his own company at the beginning of the 1990s.

Passementerie, which is often considered as the 'jewellery of the house', covers a vast amount of decorative braiding, tassels and fringing suitable for the Georgian interior. Their vast selection of historic designs and embellishments adorn some of Britain's most historic interiors. Recent work of theirs includes the sensitive re-braiding the baroque State Bed in Buscot Park, originally made for Sir Gilbert Heathcote in reign of Queen Anne.

Houghtons of York

(Established 1997)

DUNNINGTON, YORK

A) Priest's chair designed by Craig Hamilton for the new Chapel at Williamstrip, Gloucestershire
Walnut, holly inlay, gilded bronze
35½ × 29½ × 20⅝in.,
90 × 75 × 52.5cm.
2017, Private collection

B) Oak centrepiece featuring the badge of the Imperial Society of Knights Bachelor at St Paul's Cathedral
Oak
19¾ × 9 × 2in., 50 × 23 × 5cm.
2008, Chapel of the Imperial Society of Knights Bachelor at St Paul's Cathedral, London

C) Example of fine hand-carved decoration
Limewood
17⅛ × 12¼ × 2in., 43.5 × 31 × 5cm.
(2)
2011, Company collection

D) Sample of carved decoration for a stairwell post
Oak
6⅞ × 37⅜ × 1⅜in., 17.5 × 95 × 5cm.
2016, Company collection

Houghtons have supplied traditional woodwork and joinery to a vast array of historic buildings in Britain, including for the National Trust, English Heritage and Canterbury, York and St Paul's cathedrals. Alongside newly commissioned works, the company undertakes restoration work of the most delicate nature and greatest technical complexity using traditional methods.

Houghtons are the current successors to the eighteenth-century York School, which provided so much excellent work for John Carr. The high standards established in the Georgian period have been kept going ever since. A glory of post Second World War craftsmanship was Dick Reid's workshop in York, where many of his successors were trained and which produced magnificent carving for the restoration of Spencer House, London, and Windsor Castle after the fire.

The priest's chair is one of a unified group of furnishings made of walnut by Houghtons to the design of the architect Craig Hamilton for a private chapel in Gloucestershire. The complete set comprises the narthex screen, pews and kneelers, cupboards, font cover and lectern.

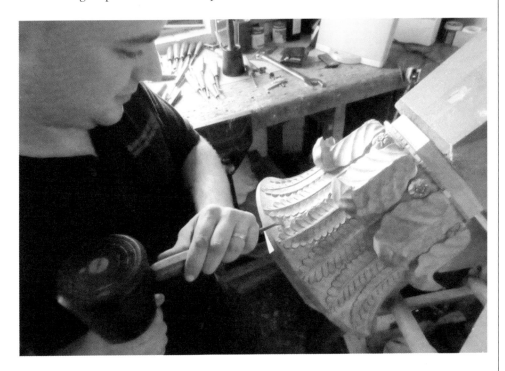

Richard Humphries

The Humphries Weaving Company
SUDBURY, SUFFOLK

A) A panel of pure crimson silk
Silk woven on a loom
79 × 21in., 200.66 × 53.34cm.
2016, Company's collection

Established by Richard Humphries in 1972 at the age of twenty, The Humphries Weaving Company has woven sumptuous silks and hangings for a wide variety of historic buildings, palaces, art galleries and museums. Humphries' initial training began whilst working as an apprentice at Warner & Sons, Braintree. On their closure he set up his own company by rescuing some hand looms and other necessary machinery to form his own cottage industry.

Since the beginning of the new century, the business has expanded by keeping true to the traditions, knowledge and craft of weaving, whilst employing new technologies to assist in the process. They produce a vast variety of historic designs, from plain, to striped and figured weaves, informed by decades of research and experience working with some of Britain's most historic interiors.

The design exhibited here is Italian in origin and dates from the 1730s. Examples of this pure woven silk can be found in many historic buildings, including at Spencer House, London.

Philip Hunt Antiques

NORWICH, NORFOLK

A) Bookcase based on original
example from Harborough House,
Leicestershire
Mahogany and glass
10ft 6in. × 14ft 0in. × 1ft 9in.,
320 × 426.7 × 53.34cm.
1997, The Georgian Group

B) A pair of bookcases
Mahogany and glass
7ft 6½in. × 5ft 0in. × 1ft 9in.,
230 × 152 × 53cm. (2)
2000, The Georgian Group

C) Bookcase
Mahogany and glass
7ft 6½in. × 5ft 0in. × 1ft 9in.,
230 × 152 × 53cm.
2007, The Georgian Group

The pair of bookcases was given to the
Georgian Group by Peter Tcherepnine
through the American Friends of the
Georgian Group, in memory of his
father-in-law, William Barclay Harris QC,
Chairman of the Georgian Group
1985–90, President 1990–99.

Bookcase C was given by the American
Friends of the Georgian Group in fond
memory of Cordelia C. Richard, Treasurer,
1995–2006.

Corin Johnson
(b.1969)

CAMBERWELL, LONDON

A) Medusa and Base
Resin and plaster
21⅛ × 15 ¾ × 7½in., 55 × 40 × 19cm.
Artist's collection

B) Hermes and Aphrodite
Marble
14⅝ × 23⅝ × 15in., 37 × 60 × 38cm.
(2)
2009, Artist's collection

C) Lion relief for chimneypiece (modelled
on original at Apsley House)
Plaster
13 × 22½in., 33 × 57cm.
Artist's collection

D) Hervey heraldic ounce maquette
(inspired by original erected by
the Earl Bishop of Derry on the
gatehouse of Downhill House, County
Londonderry)
Plaster
18⅞ × 21¼ × 5½in., 48 × 54 × 14cm.
2008, Artist's collection

E) Corinthian capital
Plaster
11 × 13¾ × 5½in., 28 × 35 × 14cm.
c.2005, Artist's collection

F) Ionic capital after the original
by architect James Wyatt for the
Radcliffe Observatory, Oxford
Plaster
20½ × 22in., 52 × 56cm.
2005, Artist's collection

G) Bust of a caryatid (modelled on an
original at Apsley House)
Plaster
Artist's collection

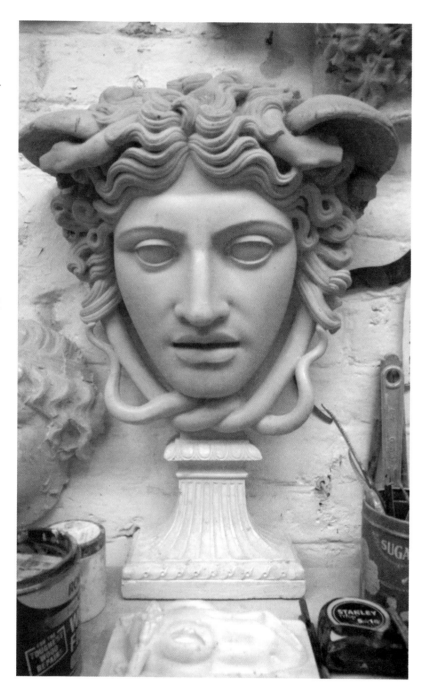

H) Bust of a caryatid (modelled on an
original at Apsley House)
Plaster
Artist's collection

I) Classical frieze (modelled on
an original from a Robert Adam
townhouse in Fitzrovia, London)
Plaster
2006, Artist's collection

J) Model of a Merlion comissioned for a
private house in Westminster
Plaster
2016, Artist's collection

Corin Johnson is a sculptor and carver working in marble, stone, wood, plaster and clay. He was drawn to art and sculpture from an early age, explaining that: 'I always enjoyed looking at carvings in churches and on buildings. Before photography and film, it was a way of capturing a person, recording an event or explaining a story or a spiritual idea. I always found something magical about sculpture and art and have always been interested in design and detail.' Born in Warwickshire, Johnson now works from his studio in London.

The pieces displayed in the exhibition reflect the broad interests of the sculptor, from the decorative to the figurative. The maquette of an ounce, a species of snow leopard which is the Hervey crest, was the model for the recreation of two full-size replica sculptures commissioned by the National Trust for the gateway of Downhill House, County Londonderry.

His most notable commissions include Two Modern Christian Martyrs in stone for Westminster Abbey and The Lady Diana Spencer Memorial at Althorp (the urn was designed by Edward Bulmer). In 2011 Johnson was commissioned to undertake a relief carving of a slave for a memorial in Wisbech, Cambridgeshire, commemorating the eighteenth-century anti-slavery campaigner Thomas Clarkson.

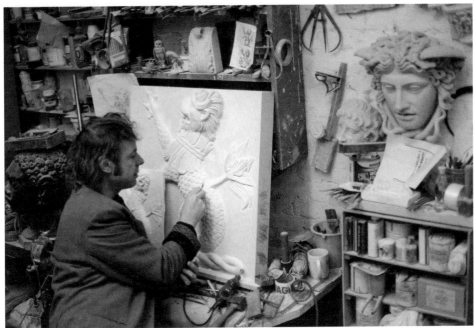

Hew Kennedy

(b.1938)

H L & S U Kennedy Trading

BRIDGNORTH, SHROPSHIRE

A) Chandelier made of sea shells
 Wood, shells, steel, brass
 83⅞in. × 47¼in., 213 × 120cm.
 2016, Artist's collection

Hew Kennedy is a Georgian virtuoso or 'amateur' of the decorative arts, and specialises in artworks when patrons experience difficulties finding originals on the antique market. A master of a wide range of obscure decorative techniques and materials, his interests span from making chandeliers in all sorts of curious materials to high-quality reproductions of arms and armour for castles. The fascination with and pleasure of experimenting with forgotten materials and skills were passed on to his son Thomas, another of the talented self-taught craftsmen featured in the exhibition.

Shellwork was a particularly Georgian craft used for small decorative objects. It was displayed in particular in the interiors of grottos such as at St Giles House, Painshill and Goodwood, all of which have been restored recently using traditional shellwork techniques. Kennedy's chandelier displays a very eccentric Georgian use of design and materials strongly influenced by a curiosity of the natural world.

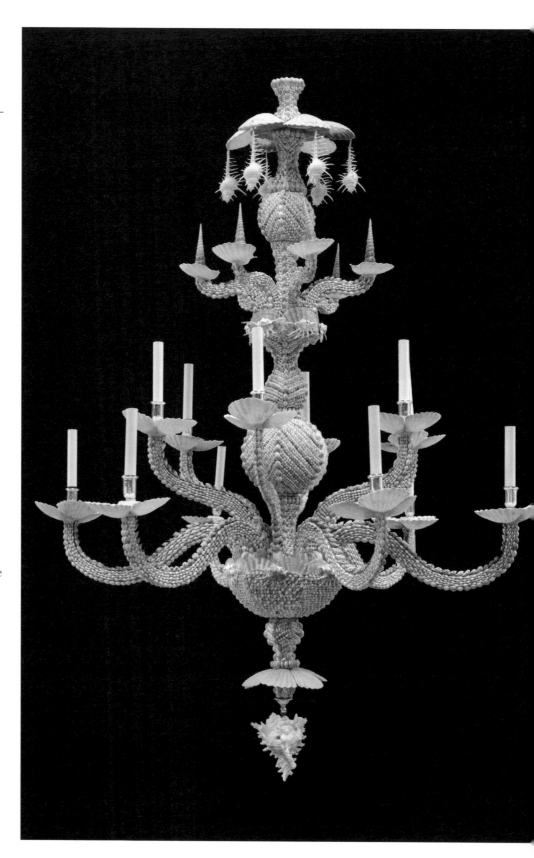

Louisa Kennedy

(b.1966)

Kennedy Design Studios

BRIDGNORTH, SHROPSHIRE

A) Cadmus and the Serpent of Ares
 Plaster-cast relief from a series
 depicting stories from Book III of
 Ovid's Metamorphoses.
 Plaster
 36 × 40⅞ × 3⅛in.,
 91.5 × 103.7 × 8cm.
 2003, Private collection

This plaster cast depicts a tale from Ovid's Metamorphoses, a popular source of inspiration for artists from the sixteenth century onwards. It features the Greek hero Cadmus (left) who defeated a serpent belonging to Ares, a victory which ultimately led to his undoing. The plaster relief also features the transformation of Actaeon, Cadmus's grandson, who stumbled upon Diana bathing with her nymphs. This particular piece forms one of a series commissioned for Millichope Hall, Shropshire. Originally modelled in clay, from which a plaster cast was made, the work displays Kennedy's traditional approach to sculpture informed by decades of practical experience.

Louisa Kennedy became interested in sculpture during her school years, where she had access to an inspiring art and ceramics department. After attending the Royal College of Art, she went on to assist with restoration of ceilings at the fire-damaged Uppark House. Her involvement in conservation and restoration continued at Windsor Castle, where she was employed to restore plasterwork in St George's Hall after the devastating fire in 1992. Louisa also collaborates with her husband Thomas Kennedy, whose elaborate scagliola work is also featured in the exhibition.

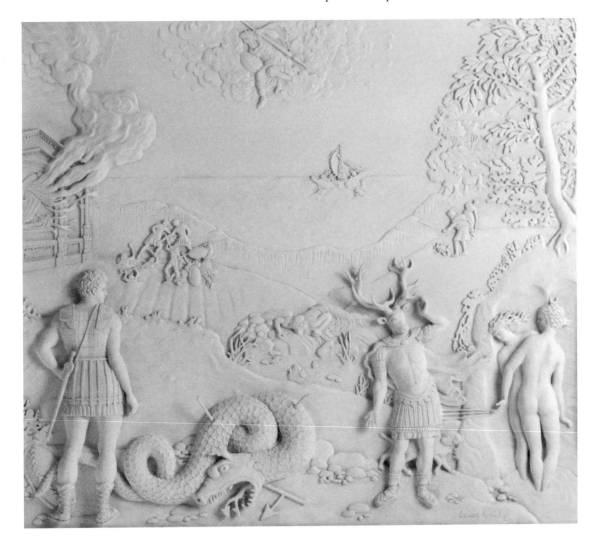

Thomas Kennedy

(b.1969)

Kennedy Design Studios

BRIDGNORTH, SHROPSHIRE

A) A pair of scagliola console table tops
34 × 47⅝in × 25⅝in.,
86.5 × 121 × 65cm. (2)
2001, Private collection

Despite scagliola being a popular decorative technique in the eighteenth and early nineteenth centuries, the craft died out in the twentieth century. Only a handful of artists have revived this medium in the present day, of which Thomas Kennedy is a leading exponent.

Scagliola was an Italian invention introduced to England in the seventeenth century. It consists of various mixtures of pulverised selenite (gypsum), mixed with glues and waxes. The complex processes involved in creating such elaborate finishes were a closely kept secret when first introduced into England.

Kennedy, a largely self-taught worker in this material, began experimenting with mixing in various colours with plaster as a part of a fascination with obscure arts and crafts techniques. His first table top commission was in 1994, and he has since received commisssions from private collectors and patrons across the country. Most notably, an exquisite neo-classical table top, designed by Thomas Messel (b.1951) and commissioned by the Countess of Derby as a present for her husband, was described in the magazine *Apollo* as 'the most ambitious and imaginative country-house furniture commissions of recent years' (November 2005).

The present pair of neo-classical console table tops are loosely based on the inlay work by the Tuscan artist Pietro Antonio Paulini (active in the eighteenth century). Alongside historically informed pieces such as these, Kennedy also creates unique and bespoke pieces of scagliola work to suit contemporary homes and settings.

The wooden bases on which these tops are supported were made for them.

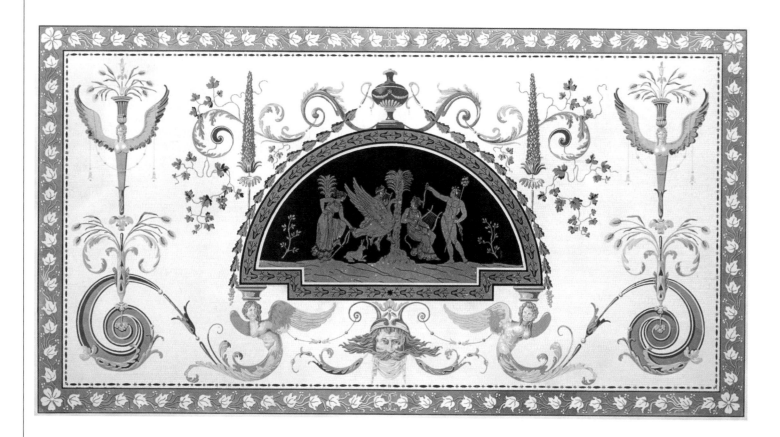

Allyson McDermott

(b.1955)

Newnham on Severn,
Gloucestershire

A) Red flock wallpaper based on original
 eighteenth-century fragment surviving
 at Temple Newsam, Leeds
 Paper, distemper, tinted varnish, wool
 flock
 78¾ × 21¼in., 200 × 54cm.
 2014, Artist's collection/White's Club,
 St James's

B) Gothic 'pillar and arch' wallpaper
 created for Temple Newsam, Leeds
 Handmade joined paper sheets,
 distemper, paint
 78¾ × 21¼in., 200 × 54cm.
 1999, Artist's collection/Temple
 Newsam, Leeds

Allyson McDermott is one of Britain's
leading authorities on conserving,
recreating and hanging historic wallpapers.
After completing her studies in the History
of Art, Design and Conservation of Fine
Art at the University of Northumbria in
Newcastle, McDermott began her practice
in the early 1980s. She has since held
several notable posts, including Paper and
Wallpaper Conservation Advisor to the
National Trust (1999–2004) and Head
of the Conservation Studios at Sotheby's
(1990–1995). Housed within a medieval
manor in Gloucestershire, and using
historically informed methods of wood-
block printing, hand painting, gilding
and embossing, her studio has produced
wallpapers for historic buildings such as
the Brighton Pavilion and the Palace of
Westminster.

Tess Morley

(b.1973)

WORTHING, WEST SUSSEX

A) A pair of shell obelisks
Shellwork
32¼ × 9 × 9in., 82 × 23 × 23cm.
2016–17, Artist's collection

B) Shell Grotesque with Protruding
Tongue
Oyster shells, cowries, screw shells
and native scallop shells
20⅛ × 14 × 4⅜in., 51 × 35.5 × 11cm.
2016, Artist's collection

C) Grotesque Male with Moustache
Oyster shells, queen scallop shells and
beach coral fragments
20⅛ × 14 × 4⅜in., 51 × 35.5 × 11cm.
2016, Artist's collection

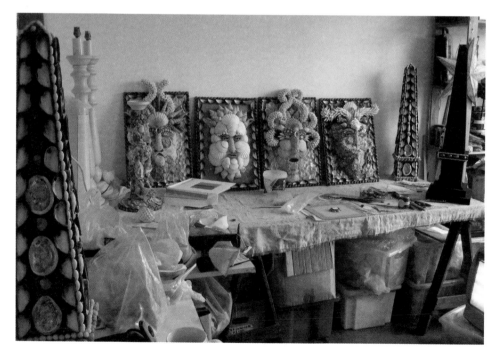

Tess Morley is one of the select group of craftsmen who work in traditional shell decoration. A typically Georgian fascination for exotic shapes inspired by the natural world, shellwork was a popular medium in which to decorate objects and in some cases cover entire rooms with fantastical encrustation.

The pieces in the exhibition display the expressive capabilities that can be achieved by using shells. Both grotesque faces share a kindred spirit with the portraits of sixteenth-century painter Giuseppe Arcimboldo, which excite the eye with playful and deceptive forms and textures. Aside from creating original artworks, Morley has worked on multiple restoration projects of shellwork grottoes and interiors. Amongst her most recent work was the restoration of the grotto at Goodwood House, originally commissioned by Charles Lennox, 2nd Duke of Richmond, for his wife Sarah Cadogan during the first half of the eighteenth century.

Owlsworth IJP

Established 1991
CAVERSHAM, BERKSHIRE

A) Lath and plaster sample
 Company collection

This sample shows the traditional Georgian method of hand-riven laths and plasterwork. This particular type of plasterwork is usually divided into various coats, including a scratch coat (first), a float coat (second) and top finish coat. The first coat squeezes through the gaps in the laths and supports the subsequent layers.

Lime plaster, which is reinforced with natural materials such as animal hair and sand, provides the most suitable finish for interior walls in townhouses such as No. 6 Fitzroy Square. In contrast to modern building materials, traditional lime plaster has excellent porosity and allows the building to 'breathe' and react to changes in the environment. The material has exceptional softness, flexibility and durability, especially in comparison to modern cements, which enables it to self-heal and respond to movement over time.

Owlsworth IJP is involved in projects on both humble and grand scales, utilising its workforce of skilled and experienced craftsmen fluent in a number of different mediums and methods. Recent projects have included constructing a new tower staircase at the Tower of London and replacing an eighteenth-century bridge at Painshill Park, Surrey.

Stephen Pettifer

(b.1972)

COADE Ltd

WILTON, SALISBURY

A) *Neptune Calming the Waves*
 (inspired by a small seventeenth-
 century marble in the Louvre)
 Coade stone
 45¼ × 23⅝ × 27⅞in.,
 115 × 60 × 70cm.
 2016, Private collection

B) Statue of *Winter* from the *Four
 Seasons*
 Coade stone
 72 × 22 × 22in., 183 × 56 × 56cm.
 2014, Private collection

C) Statue of *Spring* from the *Four
 Seasons*
 Coade stone
 72 × 22 × 22in., 183 × 56 × 56cm.
 2014, Private collection

D) Flora keystone
 Coade stone
 18 × 14⅜ × 7in., 46 × 36.5 × 18cm.
 2012, Artist's collection

E) Miser keystone
 Coade stone
 9⅛ × 8⅝ × 5⅞in., 23 × 22 × 15cm.
 2016, Artist's collection

F) Roundel based on example designed
 by James Wyatt on the Radcliffe
 Observatory, Oxford
 Coade stone
 24in., 61cm.
 2016, Private collection

G) A pair of Tigers
 Coade stone
 34 × 28 × 14in., 86 × 71 × 36cm.
 Private collection

The secret receipe for creating Coade stone was invented in the late eighteenth century by Mrs Eleanor Coade (1733–1821). Although this highly versatile sculpting material was used by some of the most eminent Georgian architects during the eighteenth and early nineteenth centuries, it had ceased to be used by the twentieth century. Stephen Pettifer, who trained in sculpture and stone carving at the City & Guilds of London Art School, revived the use of this traditional material and founded COADE in 2000. The reinvention and rediscovery of the the formulae and processes involved in creating Coade stone, which needs to be fired at high temperatures, was perfected over a considerable amount of time through trial and error. Pettifer's studio, based in the grounds of Wilton House since 2005, produces both original artworks for private patrons alongside work sensitively restoring original eighteenth- and nineteenth-century Coade stone pieces.

The pieces by Pettifer display the sculptural possibilities when using this material on both large and small scales. In comparisons with some natural stones, these sculptures will retain their detail even when exposed to harsh British weather. They also reflect the high quality of carving achieved by the sculptor and his workshop, very much on par with the high standards attained by craftsmen of the Georgian period.

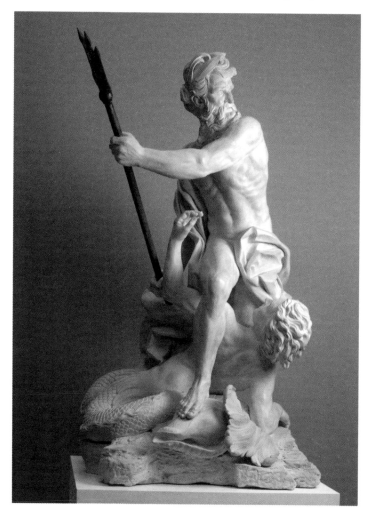

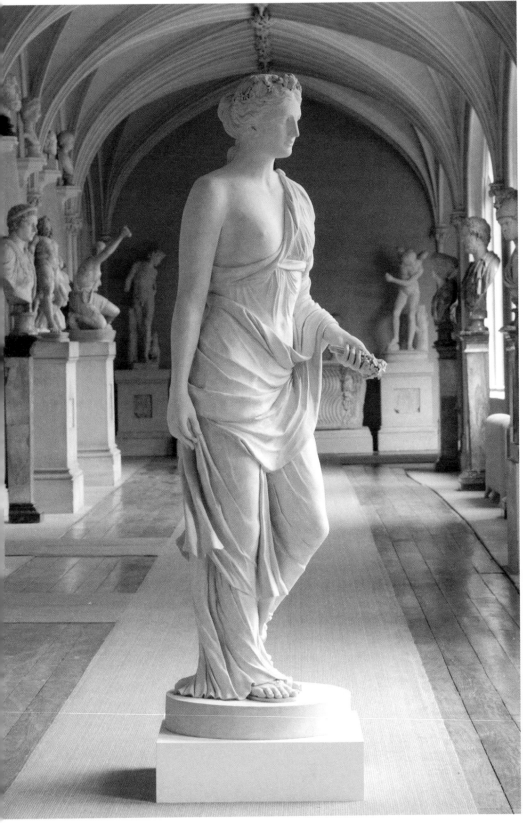

Geoffrey Preston

(b.1950)

IDE, EXETER

A) Large oval relief of Bacchus and
 Ariadne, made for Fulford House
 Plaster
 56¾in. × 108¼in. , 144 × 275cm.
 2013, Artist's collection

B) Panel of flowers after original at
 Poltimore House, Exeter
 Plaster
 24½ × 24½ × 2⅝in.,
 620 × 620 × 65mm.
 2006, Artist's collection

C) Flower study
 Plaster
 37½ × 30¾ × ⅜in.,
 950 × 780 × 10mm.
 2012, Artist's collection

D) Flower study
 Plaster
 23⅝ × 23⅝in., 600 × 600mm.
 2012, Artist's collection

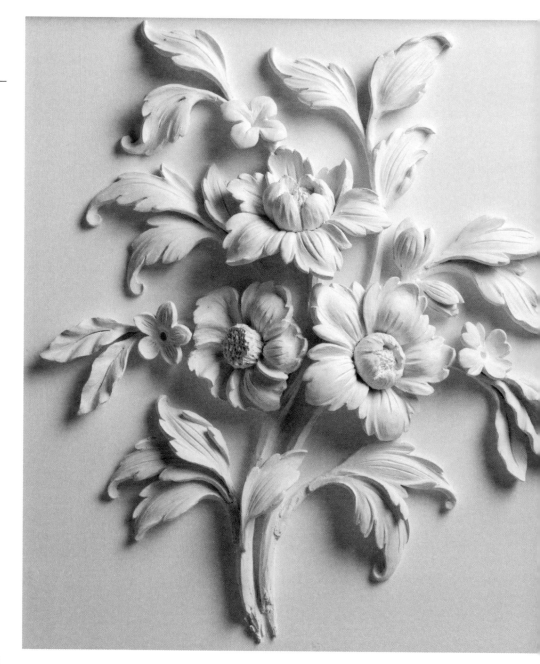

Based in Devon since 2000, Geoffrey Preston began his career as a stonemason and carver after attending Hornsey College of Art in the early 1970s. His involvement in the restoration of Uppark House was crucial after the devastating fire of 1989. This enormous restoration effort, promoted by the National Trust and supported by the Georgian Group, led to the pioneering revival of eighteenth-century methods of hand-moulding plaster and stucco work. In comparison to moulded and casted plaster, Preston and his workshop model each piece by hand in the traditional manner ensuring every element is unique.

Since the reconstruction of Uppark, Preston has become one of Britain's leading architectural sculptors, undertaking both private and public commissions for notable clients, including the large-scale stucco armorials for Sir John Thornhill's house in Dorset and the Drawing Room ceiling at Great Fulford, Devon. The relief of Bacchus and Ariadne is the seconding casting for the central ceiling panel and is inspired by a painting by Venetian artist Tintoretto. Preston's work at Great Fulford was commended in the 2013 Georgian Group's Architectural Awards for the Restoration of a Georgian Interior, where the judges noted that 'Preston has rejected timid inoffensiveness in favour of creating something vigorous and of lasting interest'.

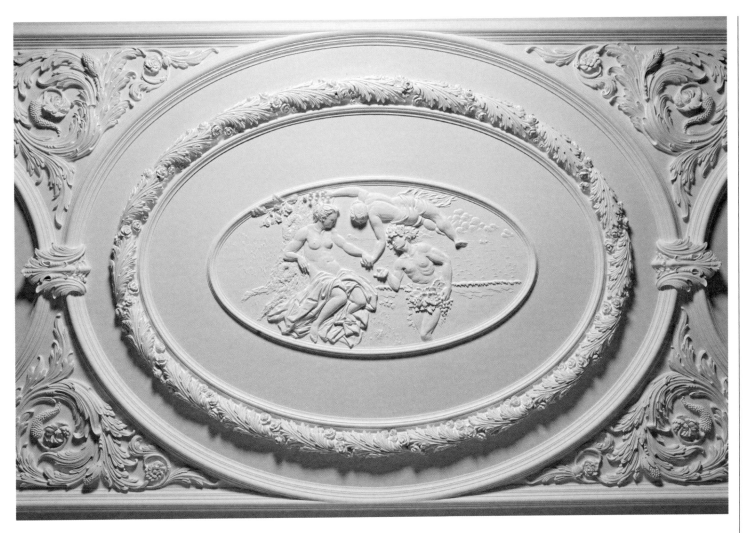

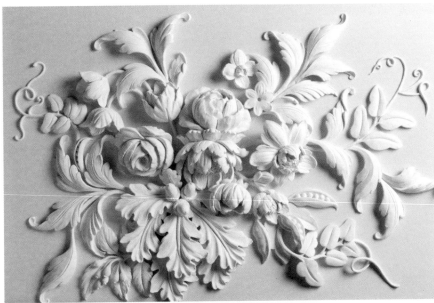

Graham Rust

(b.1942)

SOMERTON, BURY ST EDMUNDS

A) Design for painted ceiling at Kinross
House, Scotland
Watercolour and gouache on paper
11⅞ × 11⅞in., 30 × 30cm.
2011, Artist's collection.

Literature
Kinross House, *Country Life*,
11 March 2016

B) Designs for two painted panels for the
Dining Room of Kinross House
Watercolour and gouache on paper
5½ × 5½in., 14 × 14cm. (2)
2011, Artist's collection

All three watercolours are designs by Rust
for ceilings at Kinross House, Scotland.

The first depicts Mary Queen of Scots
in the central cartouche surmounted
by the Scottish crown. The four corner
cartouches show the arms of the present
and former owners of the house, including
those of its architect, Sir William
Bruce. The vignettes depict houses that
Bruce designed, including Thirlestaine,
Hopetoun and Holyroodhouse together
with a view, from Kinross House, of the
castle on the island in Loch Leven where
Queen Mary was imprisoned.

The two smaller pictures are designs for
two painted panels for the Dining Room
ceiling of Kinross House. The left-hand
panel depicts 'Flora' with a central trophy
of flowers plus plants and wildlife from the
garden and grounds of the house. The right-
hand panel shows 'Fauna' with a central
trophy of fish and game from the estate.

Rust was first inspired by the
capabilities of fresco and ceiling paintings
whilst touring the Veneto in his early
twenties. Veronese's frescos at the Villa

Barbaro at Maser, renowned for their
inclusion of figures playfully invading the
space, proved influential in Rust's desire to
practise mural painting.

His many publications on the subject of
wall painting, which include sumptuous
illustrations of his designs, have become
popular texts in the approach to mural
paintings in the modern age. The Graham
Rust mural painting workshop, which runs
each year and is heavily oversubscribed,
gives a chance for up-and-coming
artists to learn from his own experience
and technique directly. Amongst his
most notable works are the large-scale
murals in the Staircase Hall at Ragley,
Warwickshire, commissioned by the
Marquess of Hertford.

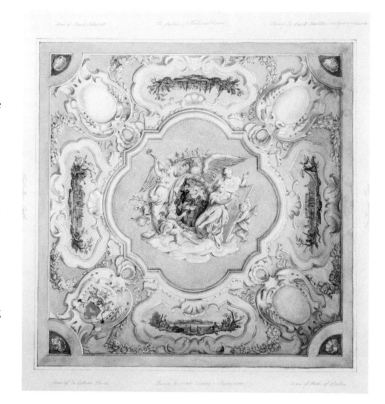

Hugo Smith

(b.1957)

Bulbeck Foundry

BURWELL, CAMBRIDGESHIRE

A) Hampton Court urns
Lead
27 × 30in., 686 × 782mm. (2)
2016, Artist's collection

B) Bulrush boy plaque
Lead
9 × 10in., 230 × 250mm.
2016, Artist's collection

C) Lion mask plaque
Lead
13½ × 15¼in., 342 × 387mm.
2016, Artist's collection

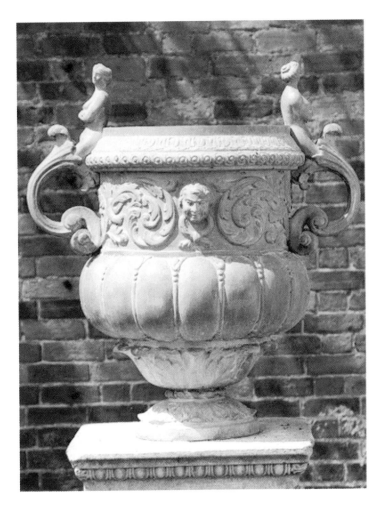

Originally founded in 1988 on the site of a disused cowshed, the Bulbeck Foundry has risen to become one of Britain's leading producers of traditional leadwork. Hugo Smith practised as a land agent prior to establishing the Foundry, an event he attributes to a chance meeting in a pub. The foundry has since supplied pieces to many of Britain's historic houses, including Hampton Court, Chatsworth, Sandringham and Clarence House.

The lead urns are copies of a set designed by John van Nost in 1700 for William III's new privy garden by Daniel Marot at Hampton Court Palace. Nost's work at Hampton Court and Melbourne Hall, Derbyshire, is often thought of as the beginning of a Golden Age for leadwork in Britain, which lasted until the late eighteenth century.

Apart from these urns and plaques, the foundry cast an enormous variety of wares from full-size statues, fountains, birdbaths and decorated cisterns.

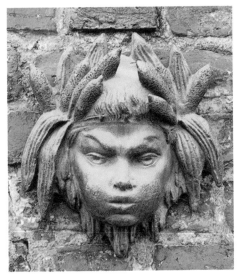

Dick Smyly

(b.1972)

Galashiels, Selkirkshire

A) Mortonhall, Midlothian
Oil on canvas
28 × 50in., 71 × 127cm.
2016, Trotter family, Charterhall,
Duns, Berwickshire and Mortonhall,
Liberton, Midlothian

B) Farleigh House, Hampshire
Oil on canvas
30 × 40in., 76.2 × 101.6cm.
2009, The Earl of Portsmouth,
Farleigh House, Farleigh Wallop,
Hampshire

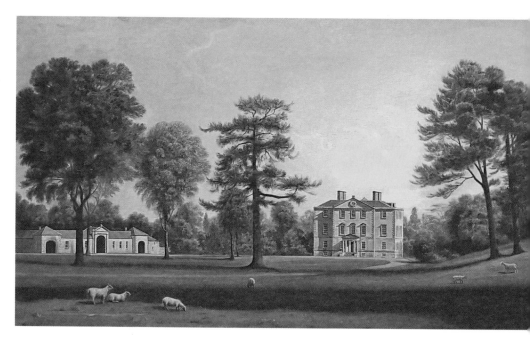

After concluding his studies at Eton College, Smyly spent a considerable amount of time in Florence dedicating himself to train as a painter in the classical manner. Although these two canvases show his talents as a painter of landscapes, his interests extend to a wide variety of subjects, including portraiture and still life in the native traditions of these isles.

These two house portraits depict two fine examples of Georgian architecture and capture the spirit of the British country house situated in its 'picturesque' parkland setting. Mortonhall, Midlothian, was built in 1760 for the Trotter family and is based on a Palladian design. Farleigh House, commissioned by John Wallop, 1st Earl of Portsmouth in the 1730s, was embellished in the twentieth century by Harry Stuart Goodhart-Rendel and remains the family seat.

Both canvases record the details of the architecture framed in mature trees, to complement each other harmoniously. Their composition and execution reflect Smyly's interest in painters such as Claude and Richard Wilson, from whom the artist draws inspiration for light and palette.

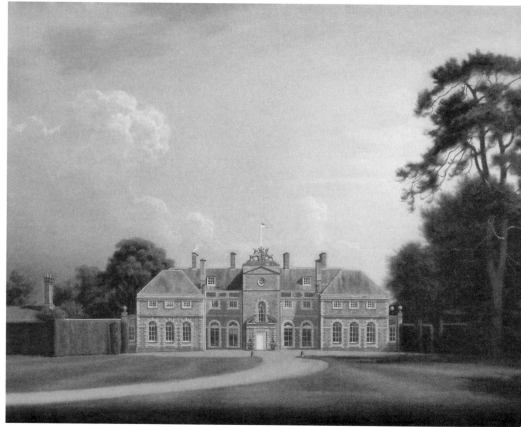

Alexander Stoddart

(b.1959)

PAISLEY, SCOTLAND

A) The God *Hypnos*
Modelled in clay
12¾in., 32.5cm height
2013, Artist's collection

B) *The Wisdom of Silenus*
Terracotta and red oxide
11¾in., 30cm. height
2014, Artist's collection

C) *Anacreon's Grave*
Terracotta
12½in., 32cm. height
2014, Artist's collection

Alexander 'Sandy' Stoddart is one of Britain's most prolific and outspoken neo-classical sculptors. In 2008 he became the Queen's Sculptor in Ordinary for Scotland, a position in the Royal Household first awarded to Sir John Steell by Queen Victoria in 1838. Stoddart's artworks occupy some of the most prominent public spaces in Scotland, including the full-size statues of eighteenth-century philosophers Adam Smith and David Hume on the Royal Mile in Edinburgh. Several classical friezes by the artist are in the Queen's Gallery, Buckingham Palace, and were installed there in 2000 as part of an extensive refurbishment by architect John Simpson.

Almost all of Stoddart's sculptures start their life in clay. These bozzetti, which serve as studies, capture the artist's initial ideas modelled with his hands and fingers.

The Wisdom of Silenus takes inspiration from Nietzsche's *The Birth of Tragedy* 1872, in which the figure Silenus represents the conflicting medium between joy and sorrow. Stoddart attributes *Hypnos*, deity of sleep, knowledge and enlightenment, to his own abstention from artistic dynamism and all forms of 'contemporism'. *Ancreon's grave*, depicting a monument of the Greek lyric poet being crowned with laurels by Eros, is inspired by Goethe's own poem on the subject.

Stoddart has previously said in interviews that sculpting is a '... technical operation of getting a shape into the world.... I have spent my life working in mud ... you have to approach this with an industrious reverence ... the artist is a frantic maniac, literally running from one end of the studio to another, if he is a sculptor, because he has to do so much work in three dimensions, and that clock is ticking away....' (*Wanderlust* filmed 2016 for Canvas.be)

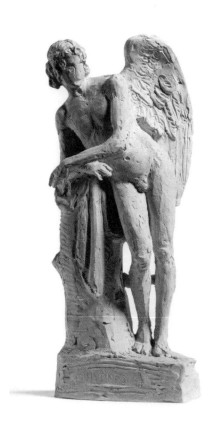 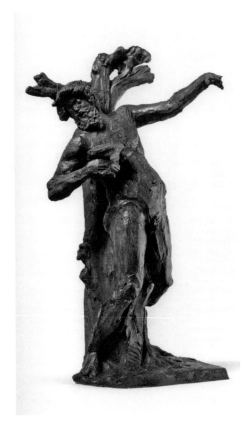 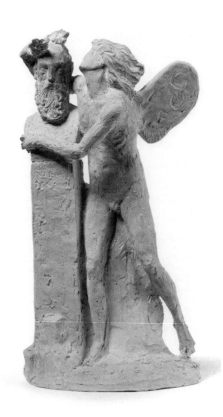

Jamie Teasdale

(b.1987)

Teasdale Bespoke

LAMBETH, LONDON

A) Octagon plinth
 Poplar wood, MDF board
 39½ × 23½ × 23½ in.,
 1000 × 600 × 600mm.
 2017

B) Square plinth
 Poplar wood, MDF board
 39½ × 15¾ × 15¾in.,
 1000 × 400 × 400mm. (2)
 2017

Jamie Teasdale studied Bench Joinery at the Building Crafts College (BCC), an educational establishment founded in 1893 to deliver high quality training in building crafts and building conservation. The BCC offers a wide range of courses specialising in carpentry, stone masonry, construction, building maintenance, historic building conservation and heritage craft skills. The college also offers a multi-crafts schools programme to children between the ages of 14–16.

Jamie's studies were undertaken as part of an apprenticeship with a local cabinet maker, and he is now a maker in residence at the BCC. This allows him the freedom to take on private commissions and build a small business from the college workshops.

Anthony Temperton

(b.1957)

Sambrook & Temperton

STOCKTON-ON-THE-FOREST, YORK

A) Fanlight
 Lead, brass and drawn restoration
 glass
 2ft. × 5ft., 60.96 × 152.4cm.
 2000, Artist's collection

B) Samples of castings for fanlights

Having been a stained-glass conservator for twenty-five years, Anthony Temperton has worked on some of Britain's most notable historic windows, including those at New College, Oxford, Wells Cathedral and York Minster. After spending twenty-five years with the York Glaziers Trust, he has spent the past fifteen years running his own company, which specialises in producing and conserving fanlights.

His fascination for the construction and design of fanlights was nurtured during his professional association with John Sambrook (1933–2001), a leading member of the conservation movement during the 1970s, who is often regarded as the figure responsible for the revival of the fanlight makers' craft in the United Kingdom.

The completed fanlight is constructed using traditional methods of casting molten metal into a mould. Instead of using wrought iron, widely used in the eighteenth century and prone to rust, Temperton uses lead and brass for the armature of his own fanlights.

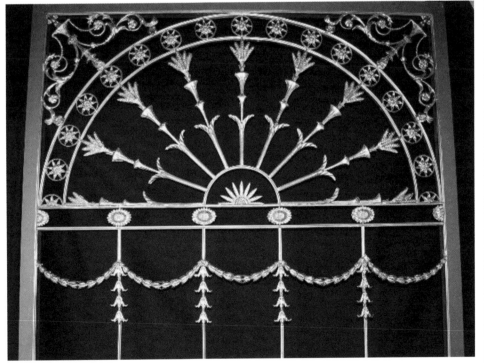

111

The London Crown Glass Company

(Established 1991)

HENLEY ON THAMES, OXFORDSHIRE

A) Three panes of Crown glass

In comparison to mass-produced and perfectly flat modern plate glass, traditional blown glass bubbles, reflects and sparkles to create a unique effect to complement the character of any historic building. Hand-blown glass, as is displayed here, follows a traditional of glass making which stretches back to antiquity.

Crown glass, which requires the molten material to be spun until a disc is formed, was the preferred glass for windowpanes until the mid-nineteenth century. This glass was used in the restoration of the two ground-floor front windows of No. 6 Fitzroy Square in 2010.

Founded by Christopher Salmond in 1991, the London Crown Glass Company is a family-run business, which has supplied window glass over four generations since the early nineteenth century. Their glass adorns notable historic buildings including Kensington Palace, Kew Palace, Windsor Castle and Alnwick Castle.

Peter Weldon
(b.1967)

Peter Weldon Iron Designs Ltd
RHYDARGAEAU, CARMARTHENSHIRE,
WALES

A) Section of a gate
Metalwork
9⅛ × 23⅜ × ⅝ in., 23 × 59.5 × 1.5m.
2012, Artist's studio

B) Section of a gate
Metalwork
35⅛ × 22⅞ × 1in., 89 × 58 × 2.5cm.
2012, Artist's studio

Peter Weldon, born in Malawi, East Africa to British parents, credits his interest and adventurous spirit in design to his youth spent in Africa. Before becoming a skilled craftsman in metalwork, Weldon had a successful career in the design and execution of ceramics. After graduating with a degree in Ceramics Design from Staffordshire Polytechnic in 1989, he eventually went on to create his own company with a special interest in recreating and copying historic Delft and Sèvres wares. His interest in metalwork began whilst living in Vietnam, where he became entranced by the beauty of French colonial ironwork surviving in that country.

Weldon works closely with his wife Louise, a designer skilled in pattern work, with whom he closely collaborates on all metalwork designs. His own approach towards metalwork is to 'plug the gulf' between the artist blacksmith and the steel fabricator, very much as it would have been in the eighteenth century. Both sections display traditional methods of hot forging completed by hand. Apart from gatework, the company also designs rose tunnels, summerhouses and bandstands in appropriate and sympathetic historical styles befitting their setting.

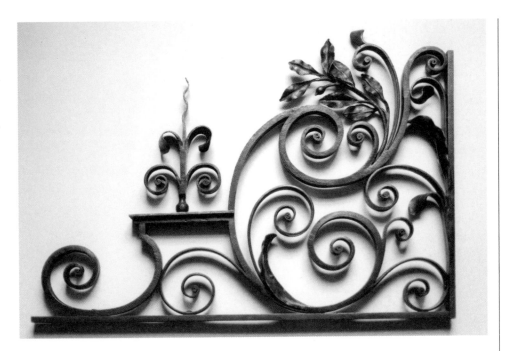

David Wilkinson

(b.1947)

Wilkinson Plc

SITTINGBOURNE, KENT

A) English crystal chandelier
 English lead crystal
 53⅛ × 66¾in. diameter,
 135 × 177cm. diameter.
 2016, Company collection

David Wilkinson carries on the tradition of glass cutting begun by his great-uncle Frank Wilkinson, who established F. Wilkinson & Co. in Stourbridge, West Midlands. David's grandfather moved the business to Battersea in 1947, where they quickly expanded to produce high-quality reproductions of eighteenth- and nineteenth-century chandeliers. They were granted a Royal Warrant as Glass Restorers in 1986, and have since completed work at Spencer House, St George's Hall, Liverpool, and the Bank of England. Most notably, they acquired Osler & Faraday in 1985, leading suppliers of quality chandeliers during the 1800s, including their precious archive of designs and drawings.

This ten-branch chandelier is a faithful recreation of an original made in 1732 for Thornham Hall, Norfolk.

Catalogue of Architectural Drawings

The ability to design classical buildings with both technical precision and aesthetic appeal in mind was an essential skill for the Georgian Architect. The following drawings exemplify this living tradition nurtured by architects in the present day.

Detail of a Chimneypiece for the New Library at Kirtling Tower by Digby Harris.

Edmund Browne

Craig Hamiliton Architects
RADNORSHIRE AND LONDON

A) Entablature of the West Doric
 Colonnade of the Forum at Pompeii
 Pen and ink
 23½ × 16½in., 594 × 420mm.

B) The Timber Screen of the House of
 the Wooden Partition at Herculaneum
 Pen and ink
 23½ × 16½in., 594 × 420mm.

C) Anta Capital found at Paestum
 Pen and ink
 23½ × 16½in., 594 × 420mm.

Robert Cox

ADAM Architecture
LONDON

A) A house for a hot climate
 Pen and ink on tracing paper
 53⅛ × 43⅜in., 1350 × 1100mm.

B) 22 Southgate Street, Winchester
 Pen and ink on tracing paper
 53⅛ × 43⅜in., 1350 × 1100mm.

Peter Folland

Craig Hamilton Architects
RADNORSHIRE AND LONDON

A) The Gainsborough Gallery,
 entrance elevation
 Watercolour
 30 × 22in., 760 × 560mm.

B) The Gainsborough Gallery, ground
 floor plan
 Watercolour
 30 × 22in., 760 × 560mm.

Roger Goldthorpe

Francis Johnson and Partners
BRIDLINGTON

B) Timber chimneypiece in the Gothick
 style for Home Farm, Hartforth, made
 by Silvanus Interiors, carved by José
 Sarabia and painted by Hesp & Jones
 Print of original drawing made in
 pencil and ink
 33 × 47¼in., 84 × 120cm.

C) The Chinese Pavilion at Chieveley
 House
 Print of original drawing made in
 pencil and ink
 23½ × 33in., 595 × 840mm.

Craig Hamilton

Craig Hamilton Architects
RADNORSHIRE AND LONDON

A) Watercolour
 62 × 28¼in., 1578 × 713 mm.
 Architect's collection

B) Pearwood model
 17 × 19 × 18in., 432 × 483 × 457mm.

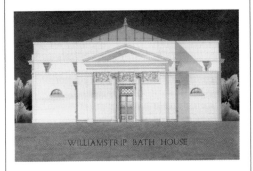

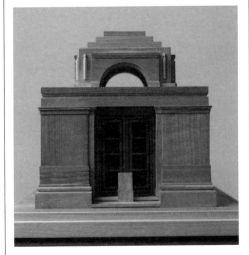

Digby Harris

Francis Johnson and Partners

BRIDLINGTON

A) Chimneypiece for the
New Library at Kirtling Tower
Print of original drawing made in
pencil and ink
33 × 49½in., 84 × 126cm.

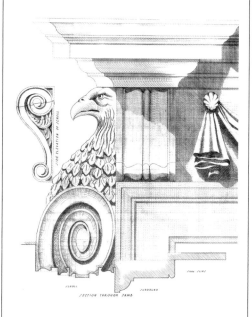

Gabriella Herrick

Peregrine Bryant Architecture &
Building Conservation

FULHAM, LONDON

A) Street elevation of Market Street in
Falmouth, Jamaica
Print of a pencil and watercolour
drawing with a photomontage
11³₄ × 47¼in., 30 × 120cm.
John Simpson

Joseph Huang

Russell Taylor Architects

LONDON & CORNWALL

A) The New Sacristy
Pen and ink
23½ × 16½in., 594 × 420mm.

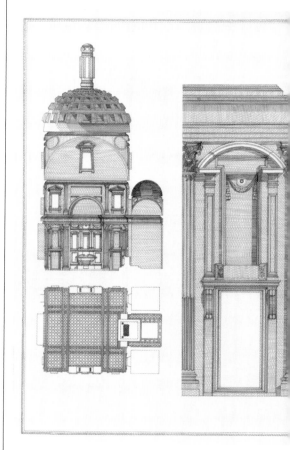

Todd Longstaffe-Gowan

Todd Longstaffe-Gowan
Landscape Design
LONDON

A) Waddesdon Kiosk
Pen and ink on tracing paper
11¾ × 16½in., 297 × 420mm.

B) Kew Pagodie
Pen and ink on tracing paper
16½ × 11¾in., 420 × 297mm.

Ben Pentreath

Ben Pentreath Ltd
LONDON

A) Fawley House
Pencil on paper
49¼ × 35¾in., 125 × 91cm.

B) Fawley House
Pencil on paper
49¼ × 35¾in., 125 × 91cm.

C) Fawley House
Pencil on paper
69 × 49¼in., 175 × 125cm.

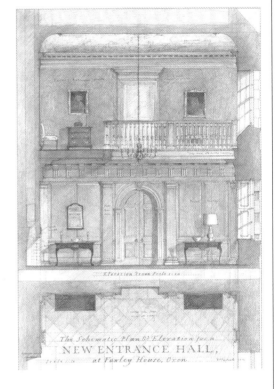

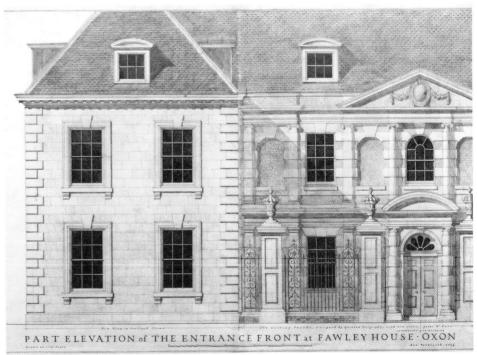

George Saumarez Smith

ADAM Architecture

WINCHESTER

A) Detail of the east façade of the new
house at Wedhampton, Wiltshire
Ink on tracing paper
44 × 24in., 112 × 61cm.
2009

B) Detail of the west façade of the new
house at Wedhampton, Wiltshire
Ink on tracing paper
44 × 24in., 112 × 61cm.
2009

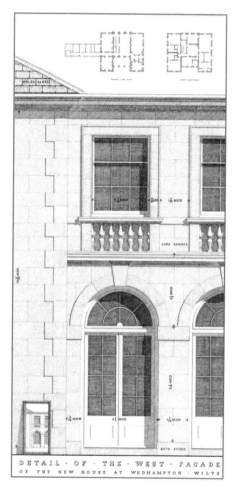

John Simpson

John Simpson Architects

BLOOMSBURY, LONDON

A) Eton, elevations of all buildings
Pen ink and wash
19½ × 26¼in., 492 × 666mm.
(sizes in frames)

B) Eton, detail of decoration in Jafar Hall
Pen ink and wash
26¼ × 36in., 666 × 913mm.

C) Lady Margaret Hall, Portico
Pen ink and wash
19½ × 26¼in., 492 × 666mm.

D) The Queen's Gallery, metalwork
details
Pen ink and wash
36 × 26¼in., 913 × 666mm.

E) The Queen's Gallery, side elevation
Pen ink and wash
19½ × 26¼in., 492 × 666mm.

F) The Queen's Gallery, front elevation
Pen ink and wash
19½ × 26¼in., 492 × 666mm.

G) The Queen's Gallery, ceiling plan
details
Pen ink and wash
19½ × 26¼in., 492 × 666mm.

Russell Taylor

Russell Taylor Architects
LONDON AND CORNWALL

A) Trewane Summerhouse
Print of pencil drawing on paper
21 × 16in., 533 × 406mm.
Architect's collection

B) Trewane Summerhouse
Print of pencil drawing on paper
21 × 16in., 533 × 406mm.
Architect's collection

Francis Terry

Francis Terry and Associates
COLCHESTER, ESSEX

A) Hannover Lodge Portico, Regent's
Park, London
Pencil and ink on tracing paper
53½ × 35 ½in., 136 × 90cm.

B) Corinthian Order for Hannover
Lodge, Regent's Park, London
Pencil on tracing paper
35 × 49½in., 89 × 126cm.

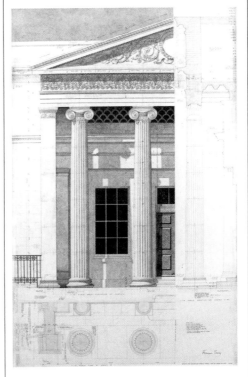

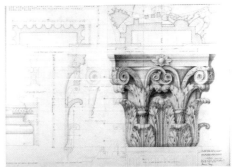

C) Full-size ceiling decoration for Kilboy
 House, County Tipperary
 Pencil on cartridge paper
 33 × 80½in., 840 × 2045mm.

D) Outer Hall at Kilboy House, County
 Tipperary
 Pencil and ink on tracing paper
 30 × 33½in., 760 × 850mm.

E) Ionic Capital for Hannover Lodge,
 Regent's Park, London
 Pencil on tracing paper
 49 × 35in., 1244 × 890mm.

F) Piranesi Ionic Capital
 Pencil on tracing paper
 35½ × 26¼in., 900 × 665mm.

G) Rinceau Panel for Hannover Lodge,
 Regent's Park, London
 Pencil on tracing paper
 33 × 24½in., 840 × 620mm.

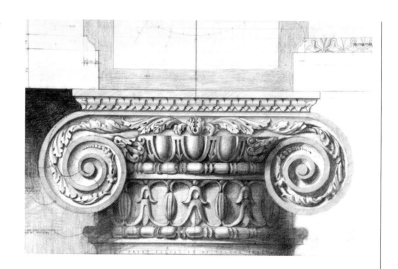

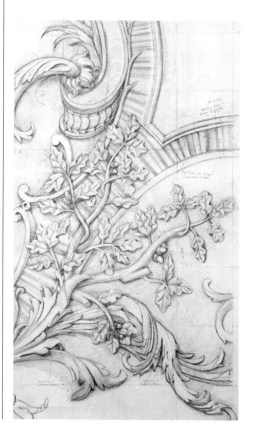

List of Exhibitors

Edmund Browne
CRAIG HAMILTON ARCHITECTS

Coed Mawr Farm, Hundred House
Powys,
LD1 5RP
01982 553312
edmund.browne@
craighamiltonarchitects.com

Edward Bulmer
EDWARD BULMER NATURAL PAINT

Court of Noke, Pembridge
Herefordshire
HR6 9HW
01544 388535
edward@edwardbulmer.co.uk

Lida Cardozo Kindersley
CARDOZO KINDERSLEY WORKSHOP

152 Victoria Road
Cambridge
CB4 3DZ
01223 362170
sorrel.bradley@yahoo.com

George Carter
GEORGE CARTER DESIGN

Silverstone Farm, North Elmham
East Dereham
Norfolk
NR20 5EX
01362 668130
grcarter@easynet.co.uk

Philip Cath
ENGLISH PORTRAITURE

07940 292424
www.englishportraiture.com
artists@englishportraiture.com

Collier Webb Foundry

Unit 2, Redward Business Park
Eastbourne
East Sussex BN23 6PW
01323 643533
Info@collierwebb.com

Chichester Stoneworks Ltd

Terminus Road
Chichester
West Sussex PO19 8TX
01243 784225
info@csworks.co.uk

Cliveden Conservation

The Tennis Courts, Cliveden Estate
Taplow
Buckinghamshire SJ6 0JA
info@clivedenconservation.com

The Marquess of Cholmondeley
THE HOUGHTON FURNITURE
COMPANY

Estate Office, Houghton Hall
Bircham Road
King's Lynn PE31 6UE
01485 528569
info@houghtonhall.com

Matthew Collins & Mathew Bray
MATHEW BRAY &
MATTHEW COLLINS LTD

Holbrook Farm Studios, Holbrook
Wincanton, Somerset BA7 8BT
01963 824336

Studio 7D/E, Vanguard Court
36–38 Peckham Road
London SE5 8QT
0207 7030171
matthew.collins@mathewbray.co.uk

Robert Cox
ADAM ARCHITECTURE

Old Hyde House, 75 Hyde Street
Winchester
Hampshire SO23 7DW
01962 843843
robert.cox@adamarchitecture.com

Alexander Creswell

01483 277311
info@alexandercreswell.com

Alan Dodd
ALAN DODD: DESIGNER & MURAL
PAINTER

www.alandodd.co.uk
0207 607 8737
dodd@alandodd.co.uk

Peter Folland
CRAIG HAMILTON ARCHITECTS

Coed Mawr Farm
Hundred House
Powys LD1 5RP
01982 553312
pfolland@live.co.uk

Clunie Fretton

www.cluniefretton.com
02076 362061
clunie.fretton@gmail.com

Kevin Gannon
FARTHING AND GANNON

Filey Cottage, Mounts Lane
Newnham
Daventry NN11 3ES
01327 310146
kevin@farthingandgannon.com

George Jackson Ltd
Unit 19, IO Centre
Kimpton Park Way
Sutton
Surrey
SM3 9BW
0208 687 9740
david.serra@georgejackson.com

Roger Goldthorpe
FRANCIS JOHNSON AND PARTNERS

Craven House
16 High Street
Bridlington
East Yorkshire
YO16 4PT
01262 674 043
info@francisjohnson-architects.co.uk

Sarah Goss
SARAH GOSS TRADITIONAL
WOODCARVING & RESTORATION

www.sarahgoss.co.uk
01730 716405
hello@sarahgoss.co.uk

De Gournay

112 Old Church Street
London
SW3 6EP
0207 352 9988
info@degournay.com

Thomas Greenaway
GREENAWAY MOSAICS LLP

www.greenawaymosaics.com
01327 861378
thomas@greenawaymosaics.com

Anthony Gregg
FINE FRAME CONSERVATION

Studio 20, Sulivan Enterprise Centre
Sulivan Road
London
SW6 3DJ
07828 331176
tony@fineframeconservation.com

Craig Hamilton
CRAIG HAMILTON ARCHITECTS

Coed Mawr Farm
Hundred House
Powys
LD1 5RP
01982 553312
admin@craighamiltonarchitects.com

Felix Handley

www.qest.org.uk/scholar/felix-handley/
07736 061533
www.felixhandley.com
felixhandley@gmail.com

Digby Harris
FRANCIS JOHNSON AND PARTNERS

Craven House, 16 High Street
Bridlington
East Yorkshire
YO16 4PT
01262 674 043
info@francisjohnson-architects.co.uk

Heritage Trimmings

The Old Mess Room
Colombo Street
Derby
DE23 8LW
01332 343953
email@heritagetrimmings.co.uk

Gabriella Herrick
PEREGRINE BRYANT ARCHITECTURE &
BUILDING CONSERVATION

The Courtyard, Fulham Palace
Bishop's Avenue
London SW6 6EA
0207 3842111
info@peregrine-bryant.co.uk

Houghtons of York

Common Road
Dunnington
York YO19 5PD
01904 489193
Fax 01904 488730
webenquiries@Houghtons.plus.com

Joseph Huang
RUSSELL TAYLOR ARCHITECTS

85 Blackfriars Rd
London SE1 8HA
020 7261 1984
joehuang@hotmail.co.uk
mail@rtarchitects.co.uk

Richard Humphries
THE HUMPHRIES WEAVING COMPANY

Ashburton Lodge, 64 Cornard Road
Sudbury
Suffolk CO10 2XB
01787 466670
fabrics@humphriesweaving.co.uk

Philip Hunt
PHILIP HUNT ANTIQUES

Whitlingham Hall
Whitlingham Lane
Trowse,
Norwich NR14 8TZ
info@decorativehomefurnishings.co.uk

Corin Johnson

www.corinjohnson.hostinguk.org/corin
01494 451258
corinjohnson@hotmail.com

Hew Kennedy
H.L AND S.U. KENNEDY TRADING

01746 714203
203churchfarm@gmail.com

Thomas & Louisa Kennedy
KENNEDY DESIGN STUDIOS

www.kennedy-scagliola.co.uk
tomandlouisa@gmail.com
info@kennedy-design.co.uk

Todd Longstaffe-Gowan
TODD LONGSTAFFE-GOWAN
LANDSCAPE DESIGN

3rd floor Greenhill House
Greenhill Rents
90-93 Cowcross Street
London
EC1M 6BF
0207 253 2100
studio@landskip.com

Allyson McDermott

Field House, Awre
Newnham on Severn
Gloucestershire
GL14 1EH
01594 510003
info@allysonmcdermott.com

Tess Morley

www.tessmorley.co.uk
01903 871399
tess.shellwork@hotmail.co.uk

Owlsworth IJP

Unit 2, Paddock Road
Caversham
Reading
Berkshire
RG4 5BY
info@owlsworthijp.co.uk
01189 469 169

Ben Pentreath
BEN PENTREATH LTD

17 Rugby Street
London
WC1N 3QT
0207 4302526
enquiries@benpentreath.com

Stephen Pettifer
COADE LTD

Sawmill Yard, Wilton Estate
Wilton
Salisbury SP2 0JU
01722 744499
info@coade.co.uk

Geoffrey Preston
GEOFFREY PRESTON LTD

Halscombe Farm Workshop
Halscombe Lane, Ide
Exeter EX2 9TQ
01392 811421
info@geoffreypreston.co.uk

Graham Rust

The Old Rectory, Somerton
Bury St Edmunds
IP29 4ND
01284 789450
gredgraverust@aol.com

George Saumarez Smith

ADAM ARCHITECTURE

Old Hyde House
75 Hyde Street
Winchester
Hampshire SO23 7DW
01962 843843
georgess@adamarchitecture.com

John Simpson

JOHN SIMPSON ARCHITECTS

29 Great James Street
Bloomsbury
London
WC1N 3ES
0207 4051285
info@johnsimpsonarchitects.com

Hugo Smith

BULBECK FOUNDRY

Unit 9, Reach Road Industrial Estate
Burwell
Cambridgeshire CB25 0GH
01638 743153
Fax 01638 743374
info@bulbeckfoundry.co.uk

Dick Smyly

DICK SMYLY ART

www.dicksmyly.com
07775 654461
dicksmyly@yahoo.co.uk

Alexander Stoddart

University of West Scotland
Paisely Campus
Paisely
PA12BE
Scotland

Russell Taylor

RUSSELL TAYLOR ARCHITECTS

85 Blackfriars Rd
London
SE1 8HA
020 7261 1984
mail@rtarchitects.co.uk

Jamie Teasdale

TEASDALE BESPOKE

07858043506
www.teasedalebespoke.com
Jamie@teasdalebespoke.com

Anthony Temperton

SAMBROOK & TEMPERTON

111b The Village
Stockton-on-the-Forest
York YO32 9UP
01904 400686
temperton@btinternet.com

Francis Terry

FRANCIS TERRY AND ASSOCIATES

Unit 6, Ash House
Vale View Business Units
Crown Lane South
Ardleigh
Colchester
CO7 7PL
01206 580528
francis@ftanda.co.uk

The London Crown Glass Company

21 Harpsden Road
Henley on Thames
Oxfordshire
RG9 1EE
01491 413227
londoncrownglass@gmail.com

Peter Weldon

PETER WELDON IRON DESIGNS LTD

Ffoshelyg Fach Barn
Rhydargaeau
Carmarthenshire
South West Wales
SA32 7DT
01267 307037
sales@peterweldon.co.uk

David Wilkinson

WILKINSON PLC

Bexon Court Barn
Hawks Hill Lane
Bredgar
Sittingbourne
Kent ME9 8HE
01795 830 000
Fax: 01795 830543
enquiries@wilkinson-plc.com

Acknowledgements

John Martin Robinson
George Carter
Khloe Sjogren-Cath

The Georgian Group would like to
thank the following individuals and
organisations for their generosity and
support.

Tim Sanderson
Richard Broyd
The PF Charitable Trust
Lord Leverhulme's Charitable Trust
The Walter Guinness Charitable Trust
The Bernard Sunley Charitable Trust
The Carpenters Company
Christopher Mann
Anonymous
Anonymous
Anonymous
The Exhibitors

Lenders
The Duke of Norfolk
The Duke of Northumberland
The Marquess of Cholmondeley
The Earl of Portsmouth
The National Trust
Francis Fulford
John Kennedy
Hew Kennedy

Len Conway, BCC
Tim Gregson
Alistair Gregory Smith
Magnus von Wistinghausen
Simon Sadinsky
Students of The Building Crafts College
Students of The Prince's Foundation for
 Building Community
Students of the City & Guilds of London
 Art School
Directors of Savills
Clunie Fretton
Felix Handley
Sarah Goss
Jamie Teasdale
Faith Waddell
Livio Mazzoleni
Hugh Petter
Charles Hind
Rosemary Baird
Livio Mazzoleni
Gilbert O'Brien
Gillian Williamson
Tim Crawley
James Mulraine
Sandy Stoddard
Simon Blacker
Lord Strathcarron
David Nichols
John Goodall
Harry Mount
Michael Neale
Hatta Byng
Francesca Herrick
Gabriella Herrick

Robbie Kerr
Amy Boyington
Eleanor Doughty
Amy Taylor, Landmark Trust
Robert Cox
Katerina Ward
Lauren Banks
Colin Hall
George Saumarez Smith
Richard Humphries
Natalie Jones, Humphries Weaving
Dominic Evans Freke
Edward Morgan
Michelle Tofi
Louise Morton Murray
Janine Catalano
Jemma Trebilco, John Davies Framing
David Serra, George Jackson Ltd
Andrea Walker, Cliveden Conservation
Philip Cath
Matthew Collins
Hugo Smith, Bulbeck Foundry
Geoffrey & Jennifer Preston
Stephen Pettifer
Corin Johnson
Thomas Greenaway
David Wilkenson
Philip Howard
Robin von Einsiedel
Tristan Hoare
Luci Stephens
Sinclair Surveyors

**Georgian Group Volunteers
& Invigilators**